The Letters
BETWEEN EDWARD WESTON
AND WILLARD VAN DYKE

The Letters

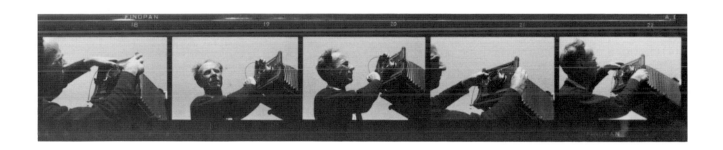

BETWEEN EDWARD WESTON AND WILLARD VAN DYKE

by Leslie Squyres Calmes

Center for Creative Photography • The University of Arizona

Design by Nancy Solomon
Typography by Typecraft
Printing by Fabe Litho, Ltd.
Laminating by Pavlik Laminating
Bound by Roswell Bookbinding

ISBN 0-938262-23-8
ISSN 0735-5572

COVER:
Left: *Weston at 683*, 1933, by Willard Van Dyke, made from
 a negative in the Willard Van Dyke Archive
Right: *Willard Van Dyke*, 1933, by Edward Weston
 Edward Weston Archive

The Center for Creative Photography is a research museum devoted
to twentieth-century photography. Among its collections are archives
of photographers who have made significant contributions to pho-
tography as an art form. Each issue of *The Archive* is drawn from
the Center's extensive collections of photographs, manuscripts, and
negatives.

Members of the Center receive an issue of *The Archive* and copies of
announcements to Center exhibitions and events. For information
about membership, write to: Center for Creative Photography, The
University of Arizona, Tucson, AZ 85721.

Contents

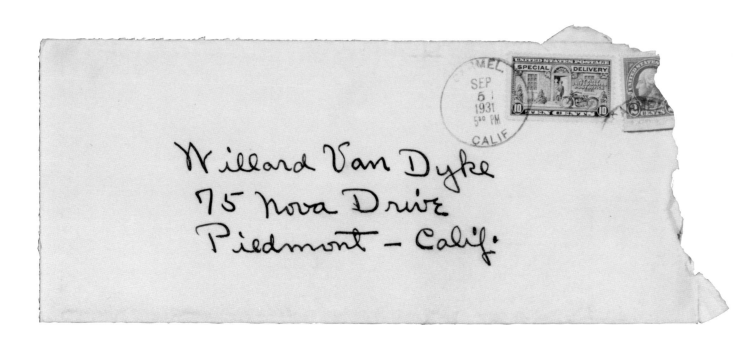

Envelope from letter from Edward Weston to Willard Van Dyke, September 5, 1931
Willard Van Dyke Archive

Envelope from letter from Willard Van Dyke to Edward Weston, July 8, 1950
Edward Weston Archive

Introduction

by Leslie Squyres Calmes

WILLARD VAN DYKE MET EDWARD WESTON in September 1928. Both artists were attending an exhibition in San Francisco at the California Palace of the Legion of Honor.[1] Van Dyke was impressed with Weston's portrait *Galván* and asked John Paul Edwards to introduce him.[2] Years later, writing his autobiography, Van Dyke described seeing his first Edward Weston photographs, "I kept coming back to them as I studied the exhibition . . . I didn't know whether I liked them or not, but I had never seen photographs that fascinated me as much."[3]

More than a year later, in November 1929, Van Dyke traveled to Carmel to study photography with Weston. Although Van Dyke had been photographing in the pictorialist style for about four years, he was dissatisfied with his work and thought he could learn from Weston. Van Dyke was just a few weeks short of his twenty-third birthday and Weston was forty-three years old. Despite the age difference, Weston and Van Dyke became friends — a friendship documented by letters spanning the twenty-six years from 1931 to 1957. When the letters begin in 1931, Weston was living in Carmel, California, and Willard Van Dyke was living in Oakland, one hundred miles to the north. Weston was an established photographer. Van Dyke was a part-time photographer, a student at the University of California at Berkeley, a gas station attendant, and still unsure of the direction his life would take.

During the years between 1931 and 1934, Van Dyke and Weston corresponded frequently. Forty-one letters are published in this book from that period and cover a range of topics including exhibitions by both photographers and Weston's first

book, *The Art of Edward Weston*. Van Dyke also spent many week-ends in Carmel photographing and talking with Weston and other artists. Weston was a visitor in Oakland less often although he did make one historic and memorable visit to Van Dyke's and Mary Jeannette Edwards's gallery/studio at 683 Brockhurst during November 1932. He wrote in his daybook that "a party was given exclusively for photographers at Willard's. Those who gathered and partook of wine and photo-technique . . . formed a group with the primary purpose of stimulating interest in real photography and encouraging new talent."[4] Group *f*/64 was formed during that evening and existed as a loose confederation of photographers for essentially three years, from 1932 to 1935. Van Dyke became more and more interested in cinematography as a way to document society and began in 1934 a gradual move away from still photography. He was interested in documenting the effects of the Depression and thought that filmmaking would prove to be a fast and effective way to present issues and to create social change.

Beginning in 1935, the men wrote less often. Thirty-three letters cover the next twenty-two years. Each made a major location change in 1935 — Weston to Santa Monica to open a portrait studio with his son Brett, and Van Dyke to New York City to pursue documentary cinematography. Edward Weston received the first John Simon Guggenheim Memorial Foundation Fellowship given to a photographer in March 1937. The Guggenheim fellowship and its renewal in 1938 allowed him to work exclusively on his photography

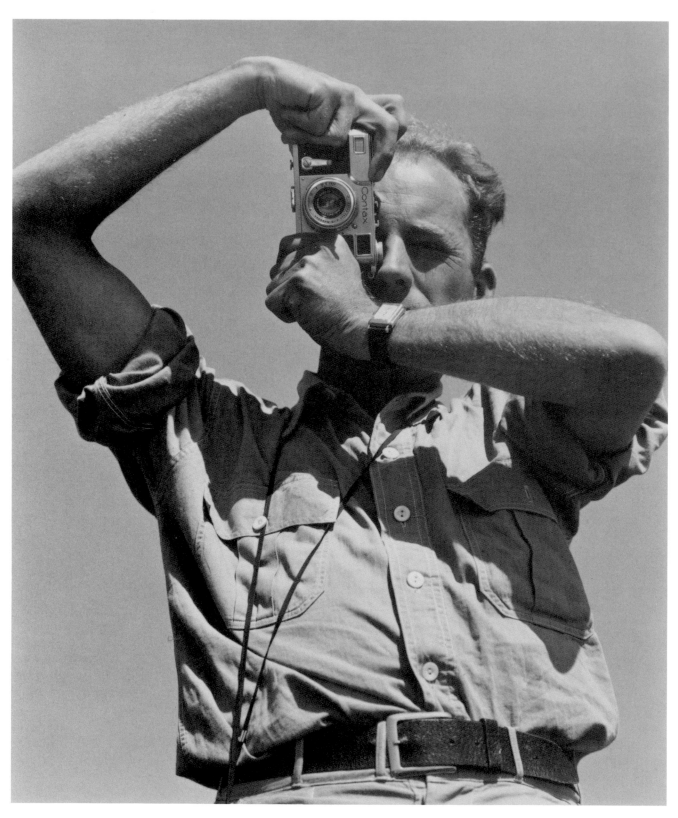

Edward Weston: *Willard Van Dyke With Contax*, 1937 81:276:051

without the constraints of making a daily living. He produced more than fifteen hundred negatives during those two years. Van Dyke arranged to make a short trip with Weston and Charis Wilson on one of their August 1937 Guggenheim journeys.[5] On this trip with Weston, Van Dyke made some of his last photographs before concentrating for the next thirty years on documentary filmmaking. Van Dyke said, "That trip provided one of the most prolific periods of photography I have ever experienced. Everything worked together — the weather, the company, and the varied landscape. The photographs that I made that year remain among the best I ever did."[6]

Edward and Charis Wilson Weston co-authored numerous publications during the forties including *California and the West* in 1940, an account of their Guggenheim years. The Westons remained in California during World War II and were volunteers in the Ground Observer Corps, Aircraft Warning Service. Van Dyke produced documentary films for the United States Office of War Information. Edward had a major retrospective of his work at the Museum of Modern Art in New York in 1946. In 1947, Van Dyke and his documentary film company, Affiliated Film Producers, persuaded the United States State Department to finance a series of films about American artists. *The Photographer*, Van Dyke's documentary tribute to Weston, was directed and photographed by Van Dyke during the summer and fall of 1947. He and Weston traveled to various points in California including Point Lobos and Death Valley. During the filming of *The Photographer*, Weston experimented with color photography at many of his favorite sites. These color transparencies were among the last images Weston made. Parkinson's disease was beginning to make it difficult for him to photograph.

Weston's health continued to deteriorate in the fifties. With the help of Brett and Cole Weston, Edward selected twelve photographs to be published as the *Fiftieth Anniversary Portfolio* in 1952. Lou Stoumen directed *The Naked Eye* in 1956, a film about photographers including Weston. Van Dyke began producing documentaries for television and industry during this time. The seventeen letters between 1950 and 1957 document a continued friendship with an exchange of letters several times a year. When Van Dyke traveled to California to lecture about documentary films in 1954, he and Weston had a brief, last visit. Weston died at his Wildcat Hill home in Carmel on January 1, 1958.

Willard Van Dyke continued making documentary films until he was asked to be the Director of the Film Library at the Museum of Modern Art in 1965. He served in this capacity until 1974. Just prior to his retirement he was asked by John Szarkowski, director of the Department of Photography, to guest direct a retrospective of Weston's work. This 1975 exhibition was Van Dyke's final tribute to Weston.

The seventies brought a renewed interest in Van Dyke's early photography and exhibitions of his work followed. He returned to still photography in 1977 and traveled to Ireland to photograph in 1979 and 1980. The last years of his life were spent working on his autobiography while living in Santa Fe, New Mexico. In 1985 he was named the first Artist Laureate in Residence for Harvard and Radcliffe. He planned to finish editing his manuscript at Harvard but died en route to Cambridge, Massachusetts, on January 23, 1986.

Willard Van Dyke sent the Center for Creative Photography what was to become the core of his archive in 1985. After his death, his wife Barbara donated additional materials. The bulk of the Weston letters to Van Dyke were found in a family garage in 1991 — apparently undisturbed since Willard left California. We are indebted to Barbara for donating these additional letters.

The Edward Weston Archive at the Center for Creative Photography was acquired from the sons of Edward Weston in 1981. Through their devotion to their father's work, we are privileged to have access to Edward Weston's correspondence, daybooks, scrapbooks, and photographic materials. The Edward Weston Archive contains all letters from Willard Van Dyke.

Other related archives at the Center for Creative Photography provided additional information about Edward Weston and Willard Van Dyke. The Ansel Adams Archive, Sonya Noskowiak Archive, Dick McGraw Archive, and the Beaumont and Nancy Newhall Collection were all valuable resources in the research.

The letters between Edward Weston and Willard Van Dyke provide insight into photography of the thirties. Cameras, films, exhibitions, and expeditions are all discussed in the letters. Weston's encouragement of Van Dyke as a young photographer, and later his enthusiasm for Van Dyke's cinematography career, are threads connecting all the letters. But unlike books, "letters . . . are a form of narrative that envisages no outcome, no closure . . . Letters tell no story, because they do not know, from line to line, where they are going."[8] Rather, letters offer clues to the writer's personality, ideas, and era. Reading the letters between Edward Weston and Willard Van Dyke, one is offered a look at the lives of each man but not the entire story. It is hoped that these letters will provide some clues to further research.

Of the eighty-six letters between Weston and Van Dyke at the Center for Creative Photography, seventy-four are included here. Twelve letters of limited informational value were not published. An inventory to the letters precedes the index. Routine spelling errors were corrected while idiosyncratic spellings of the authors were retained. Brackets signify an editorial addition to the letters, and are used to clarify a proper name only on the first occurrence of a name in any letter. Endnotes follow the letters. Both letters and notes are indexed.

NOTES

The Willard Van Dyke Archive is abbreviated WVDA.

[1] This exhibition may have been the Fifth International Salon of the Pictorial Photographic Society of San Francisco, which *Camera Craft* editor Sigismund Blumann reviewed in an article in December 1928. The Fifth International Salon was an invitational exhibition, and Weston is listed as having "graced the show."

[2] Pictorial photographer John Paul Edwards was a member of the selection committee for the Fifth International Salon and exhibited his own photographs as well. He was also the father of Mary Jeanette Edwards, co-owner of the gallery 683 Brockhurst with Willard Van Dyke.

[3] Willard Van Dyke, unpublished autobiography, pp. 42-43, WVDA.

[4] Nancy Newhall, ed., *The Daybooks of Edward Weston, Volume II. California*, (New York: The Aperture Foundation, Inc., 1973), p. 264.

[5] Van Dyke, Weston, and Charis Wilson traveled along the northern California coast for seven days early in August 1937. In one of several letters to Mary Gray Barnett, his fiancée, Van Dyke writes, "The stuff he [Weston] is doing is *very* beautiful but always in his work is the thought of FORM primarily, subject material is the last consideration." And a few days later he writes, "Yesterday, for four and a half hours Edward worked with details of old stumps, while I lay in the sun. I cannot understand how anyone can hammer away, year after year at the same subject material. It is almost as if he felt that if he could just keep his head under the black cloth, resolving problems of form on the ground glass, he would never have to look at the larger world of humans and their problems. But he is a sweet person and I certainly mean no criticism of his way of working. It is only that I don't understand it." (8 and 12 August 1937, WVDA.)

[6] Willard Van Dyke, unpublished autobiography, pp. 134-35, WVDA.

[7] In a letter to Weston, Van Dyke said of *The Photographer*, "I'm happy that I could express my love and appreciation in my own way." (3 March 1950, EWA, and reproduced here as Letter 59)

[8] A. S. Byatt, *Possession: A Romance*, New York: Random House, 1990, p. 145.

The Letters

BETWEEN EDWARD WESTON
AND WILLARD VAN DYKE

Dear Willard
and Mary Jeannette

So thoughtful, and dear of you
to send the package of surprises!
I, we, appreciated the gesture,
and our hearts warmed.
I came near to wiring you to
come this week end if you could.
Ramiel of whom I have spoken so
often came with Merle armitage.
He,—Merle, is showing his print
collection at Gallery, and will speak
tonight on the "Impresario Racket."
I did not wire, because we have
been invited out "everywhere" and
could not be with you.
But they will come again ———

affectionate greetings from all — and Edward

Letter from Edward Weston to Willard Van Dyke, June 21, 1931, Willard Van Dyke Archive

Letter 1 **[early 1930s]**
[No return address]

Dear Edward:

Did I leave my extension bed for my camera there? If I did, would it be too much trouble to send it to me? I don't know where I left it, but I hope it was there.

Also, if you think about it in time, will you write some little blurb about the show for the paper there?[1]

I had a wonderful time, in fact all the way home I was very stimulated — my mind and my senses worked overtime.

The country is lovely — another week and all the blossoms will be starting to come out.

Love,

Willard

Letter 2 **21 June 1931**
Carmel-By-The Sea, California

Dear Willard and Mary Jeannette[2]

So thoughtful, and dear of you to send the package of surprises! I, we, appreciated the gesture, and our hearts warmed.

I came near to wiring you to come this weekend if you could. Ramiel [McGehee] of whom I have spoken so often came with Merle Armitage. He, Merle, is showing his print collection at [Denny Watrous] Gallery, and will speak tonight on the "Impresario Racket." I did not wire, because we have been invited out "everywhere" and could not be with you. But they will come again —

Affectionate greetings from all — and Edward

Letter 3 **5 January [1932]**
75 Nova Drive, Piedmont, California

Dear Edward

I must tell you once more how much I appreciate your fine gift to us. All I can say is that it shall

be a goal for me. I can only hope that someday I can do something in my own way that will say as much.

Our trip home was pleasant and fast — just two hours and forty-five minutes and never faster than fifty-five miles per hour.

I have developed my films and at least have one good one of you if nothing else which certainly makes the trip worth while. What a fine time I had Monday. How much I enjoy being with you and Sonya [Noskowiak]. I think we will have a fine time on our trip. Do you think the last two weeks in March and the first week in April will be all right?

I forgot the [Kenneth] Rexroth[3] article, would you mind sending it sometime? I shall return it intact.

Much love to all of you,

Willard

Letter 4 **[undated; possibly January 1932]**
[No return address]

Dear Willard —

I can only hope that you will go on from where I leave off: so it should be —

I too got a fine negative from our expedition — the tree — it is printed and will go to N.Y.[4]

I am reprinting all negatives for N.Y. on Velour Black. I think I would use it if the colour was purple — the prints are so far superior.

The date suggested for our trip suits me. All depends upon economic conditions at the time!

I think I'll select my print from your coming exhibit.[5]

Would you ask John Paul [Edwards] for me (I don't like to keep bothering him), and write me, when the Graflex is likely to go forward. Chan is to ship Brett's Graflex to him when the new one arrives. Brett is now in L.A. but is going to Santa Barbara, and there is no use chasing him around with an express shipment. Also it would help Brett in planning dates for several sittings in view. Thanks!

Love to you, M.[ary] J.[eannette] too —

Edward

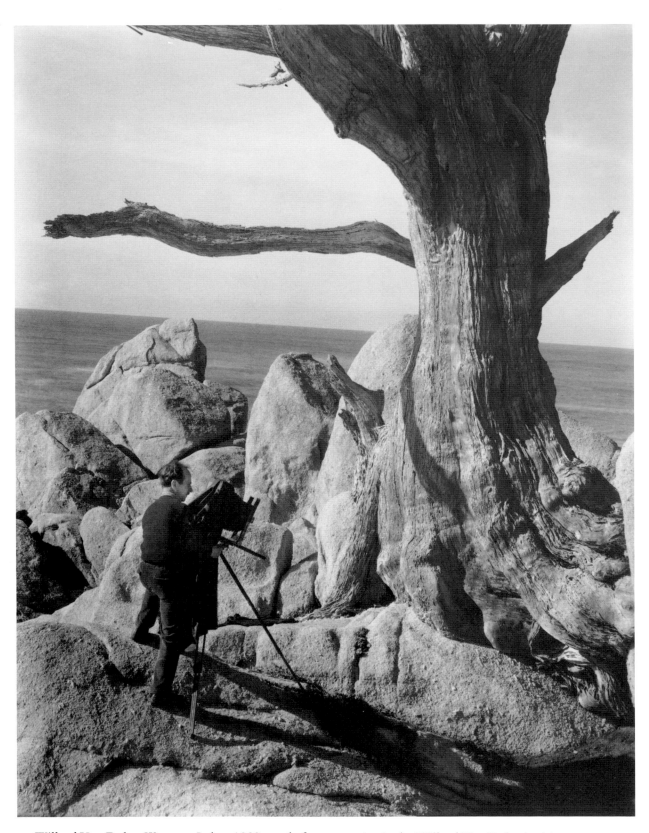

Willard Van Dyke: *Weston at Lobos*, 1930, made from negative in the Willard Van Dyke Archive

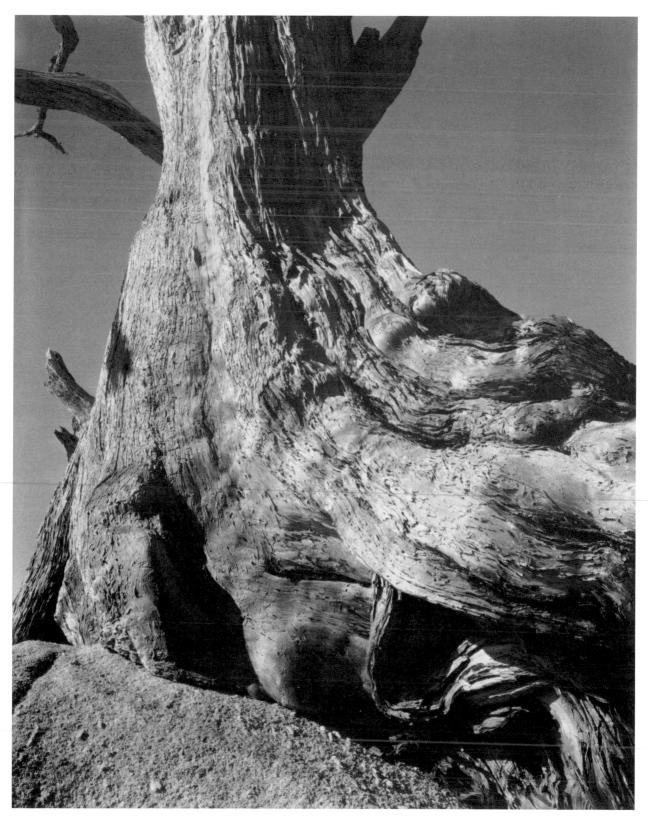

Edward Weston: *Cypress, Pebble Beach*, 1932, Edward Weston Archive

Letter 5 20 January 1932
Carmel, California

Dear Willard —

I thought the portrait of "me and tree" was excellent. You had a few surface discolorations, — looked like old hypo, — thought you should know.

Chandler writes "the camera is a beauty". It was fine of John Paul! — more concrete appreciation later. If you see a 4.5, 10 in. lens, 2nd hand, "cheap", — let me know.

Velour Black notes: there is no appreciable difference between the normal grade and contrast! I have to resort to N.B. [Novabrom] Xtra Vig. when I want extreme contrast. Too bad. Also V.B. [Velour Black] regular is a bit too contrasty for some of my negs. and they make no softer grade. Otherwise it's "swell". But more bromide, means more green!

Fine about your exhibits — and talk! — a new role for you?

I will try J.P.'s formula.

No more now. I'm printing (re-) with enthusiastic intensity!

Greetings and love from Edward

Willard Van Dyke
Preston Holder, 1934
Made from negative in the
 Willard Van Dyke Archive

Letter 6 17 February 1932
Carmel, California

Dear Willard —

We have missed you and Mary J. I have been busy as you can guess with details of N.Y. exhibit, now ready to ship, — probably Friday or Saturday.[6] Have added a few new things, — five made this year. So at least I'm not going backward. I enclose proof of catalogue. Will see that John Paul receives one.

Oh this problem of permanence! I feel that I only dodge it. Someday I'll pay a laboratory to give me data, — someone disinterested or unbiased. How about information from U. of C. [University of California] through Preston [Holder]? Well the prints look "swell" today!

Glad to know you have been working — "Business" rotten here too. I have had no sittings since before Xmas! But I don't give myself time to think.

Arizona, depends upon pecuniary circumstances — No? I still have hope — Come when you can, and we'll kill the fatted cabbage, or something.

I had hoped to have you O.K. my N.Y. exhibit. But I must send on now.

Love to you and Mary J. —

Edward

[enclosure: announcement for Delphic Studio exhibition]

Letter 7 3 March 1932
75 Nova Drive, Piedmont, California

Dear Edward,

. . . As nearly as I can tell by the detail maps I have here, our trip to New Mexico will cover about 2625 miles round trip. This is about 300 miles less than we figured while I was there in Carmel. The

¶ I have no unalterable theories to proclaim, no personal cause to champion, no symbolism to connote. Too often theories crystallize into academic dullness,—bind one in a strait-jacket of logic,—of common, very common sense. To be directed or restrained by unyielding reason is to put doubt as a check on amazement, to question fresh horizons, and so hinder growth. It is essential to keep fluid by thinking irrationally, by challenging apparent evidence and accepted ideas,—especially one's own.

In a civilization severed from its roots in the soil,—cluttered with nonessentials, blinded by abortive desires, the camera can be a way of self-development, a means to rediscover and identify oneself with all manifestation of basic form,—with nature, the source.

Fortunately, it is difficult to see too personally with the very impersonal lens-eye: through it one is prone to approach nature with desire to learn from, rather than impose upon, so that a photograph, done in this spirit, is not an interpretation, a biased opinion of what nature *should be*, but a *revelation,*—an absolute, impersonal recognition of the *significance of facts.*

The camera controlled by wisdom goes beyond obvious, statistical recording,—sublimating things *seen* into things *known.*

"Self expression" is usually an egotistical approach, a willful distortion, resulting in over or understatement. The direction should be toward a clearer understanding through intentional emphasis of the fundamental reality of things, so that the presentation becomes a synthesis of their essence.

Edward Weston

Carmel, California: February 1932

Exhibition announcement: Delphic Studio gallery, February 1932, Willard Van Dyke Archive

Death Valley trip would be a little less than half as far.

I still have hopes even tho things are not so good here. Mary J. and I almost feel like casting good judgement to one side regardless of consequences. Perhaps we could find some place to settle there. I'm tired of this damned city. I'm tired of worry and grubbing for a few lousy pennies. The whole thing stinks too loudly of futility. More and more my thoughts return to the time when I was a kid on a little farm in Colorado and how swell the days were to me then. There's much work to be done and the time is sliding swiftly by.

Thanks for the letter: I shall lay aside my camera for a time.

The most thrilling time I ever had was the week I spent with you in 1929. The very air was filled with your energy and vitality. Perhaps we shall recapture it in New Mexico.

Please excuse this disjointed letter, written with the smell of gasoline in my nostrils.[7]

Love to all,

Willard

Letter 8	5 March 1932

Carmel, California

Dear Willard,

You are after my own heart — "tired of worry and grubbing for a few lousy pennies" — it "stinks too loudly of futility." Very early, in my twenties, I made my choice. I knew that I could make money — I refused to pay the obvious price. I have no regrets. My generation, most of them, have lost everything: they have no more than I have, after their slavery. At least I have had a rich life —

Of course with dependents there is always some compromise. My present studio, overhead, is one. But I am waiting for the first hunch, opportunity to shake it all off! A few friends, a few books, a chance to play, and to develop oneself, what more! Of course the setting — for me — must be somewhere with soil and sky — no pavements, (we may allow one good highway) no sad faced people canned in dreary rows of fusty houses. I don't know when or how, but I feel it's coming, — some change.

5

It's a thrill, and right to throw aside good judgement, to disregard consequences. I did when I left the "unlovely level of 10,000 good people" — who were giving me a good living — and went to Mexico. These good people were scandalized, I had "run away" with another woman! Bah! — the woman was incidental, I was escaping their own suffocating breath. But I returned and did my finest work to date in their midst. After all, it's the gesture that counts, that strengthens.

I did not intend to write more than a line! — just to say that unless something happens I cannot imagine how I can make the proposed trip. But I have not given up hope. I don't want to keep you in suspense. I'll write you again more definitely in a week. Perhaps you will know by then too.

An interruption — which resulted in the sale of one of my rocks. Good omen! And a letter from my sister from N.Y. with the first news of my exhibit. Ira W. Martin bought the "Shell and Rock — Arrangement" the first day.

I enclose a clipping which don't bother to return. Things are stirring in N.Y. photo-circles! I'm showing at a good time.

Greetings and love to you and Mary J.,

Edward

[Enclosure: *New York Times*, 28 February 1932, two letters to the Art Editor. One letter is from Alfred Stieglitz, and the other is from Herbert J. Seligmann]

Letter 9 14 March 1932
Carmel, California

Dear Willard —

I am sad to write this letter: already you have guessed, — we cannot go — not now — on the proposed trip. It has now been two months since I've had a sitting! I have sold a few prints here, and seven so far in N.Y., — but only enough to keep going, really less than enough.

I feel quite guilty, keeping you waiting, guessing, — and I do hope that your exhibit will not suffer as result.

I will not even have a camera to work with soon, for I am sending mine, or maybe taking, it to Chandler. It may mean cash to him. I can take a vacation from "creative" work for awhile, — it may do me good![8]

My exhibit was well timed, — by chance The European group, Stieglitz and my show, all on at same time! I guess there were some hot controversies in photo circles! Will relate more when we next meet.[9]

So far as I am concerned, I feel the trip only postponed — I am really more concerned over the disappointment you and M. J. may feel.

Love to you both —

Edward —

Letter 10 21 April 1932
Carmel, California

Dear Willard —

I knew you must be very busy with preparation for the coming show. We half expected you these last weekends, — probably more desire than actually expecting. We are planning to go north at the time of your exhibit (I have forgotten the opening date), for I want to see it on the walls.[10] But first I am going south to visit my "chain studios",[11] probably leaving Monday or Tuesday next. Brett opened with an exhibit in Santa Barbara. Dated five sittings the first day! Guess I had better apply for a job! He will succeed.

Too bad Death Valley failed you, or you it! But I'm glad you got something from your effort.

Yes, I have much to tell you about New York. I really got some excellent notices. Eight prints sold — not bad nor good — three of the "Shell and Rock", which astonished me. I do not consider it one of my best. But N. York likes sensation. We will discuss N.Y. and Death Valley when we meet.

I, we, indeed 80% of Carmel was disappointed in Kreutzberg.[12] I felt nothing creative, at best a fine showman, with several group numbers no more than Vaudeville and not so honest. He was "panned" in "The Carmelite." But I photographed him (Brett did too the day after in S. B. [Santa Barbara]) and have a "swell" head.

It's a good sign, to lose old idols —

I almost wanted to go north to see Moholy Nagy[13] — from what you say I have no regrets.

Edward Weston
Harald Kreutzberg, 1932
Edward Weston Archive

to be good! Merle's part anyway. As for me, I have had a hell of a time selecting — fought with my-self — and [Henrietta] Shore and Sonya for a week — wish you had been here. I suppose I'll never be quite satisfied. Much easier to select a hundred!

I don't like the superlatives used in the an-nouncement — not a question of modesty — but good taste — well enthusiasm is infectious — may sell the book, which by the way I don't expect my friends to buy![14] I'm sure I couldn't afford it. You might be able to "place" a couple of these? I like the spirit of your letter — Tell the "pseudos" they use their intellect(?) too much — that's their disease though — no hope! It's the only way they can get a hearing in a busy world — talk — talk. But let us talk soon — I hope so — or we need not talk — we can walk — or run — or lie in the sun —

I have to write the, or a, statement for the book this week — more sweat — better come down and fight me or agree —

Love always, and to M. J.

Edward

Have saved Preston's poem to read when I'm sane —

Love to you and Mary J. —

Edward

[written in margin of letter: "Your new address?" Letter is addressed to 16 Prospect Road, Piedmont, California]

Letter 11 26 July 1932
Carmel, California

Dear Willard —

I have been sweating my guts out with this book — has to be done within time limits, because Merle is on a vacation soon to end. I think it's going

Letter 12 10 October 1932
Carmel-By-The-Sea, California

Dear Willard —

Thanks for your card. Naturally I am rather pleased! Ironical, that Joshua Tree, 1928, should have won! Someone told me that Ansel got fourth, and you seventh? I don't know how much cash that means to you: didn't know there was a 7th.[15]

How you tempt me by: "shall we go?" Nothing would please me more. But I'm afraid I'll be tied down till the book is out. In fact may have to go to L. A. I am needed to watch first prints go on press, and also to sign 500 copies! Merle, Ramiel, and [Lynton R.] Kistler the printer have been here for a "conference." Sounds like a board of directors! Brought along a new and much better "dummy." It's going to be a fine looking book, and reproduc-tions beyond my fondest hopes. The enclosed was not considered good enough.

I need to get away. Getting stale. Really need to

7

TO THE ADMIRERS OF THE WORK OF EDWARD WESTON

THIS announcement is addressed to a small group of the friends of Edward Weston, which will explain the somewhat intimate nature of its contents. For the past several years, there has been a demand for an Edward Weston book. Most of his admirers want one. But to produce an Edward Weston book, and retain the subtle quality of his inimitable work requires time, a great love for the job, and until now, a prohibitive amount of money. A remarkable thing has happened. One of the finest printers on the coast has offered to produce the book for only enough to cover the cost of the materials. They have equipment which makes them one of the few presses in America capable of handling such a job, and they want the Weston book to be an example of their superior workmanship. A photo-engraver will co-operate for the same reason. This makes it possible to produce a limited edition of 500 signed Weston books, for exactly one half the cost under ordinary conditions. Five hundred dollars is already available for this book. If you will order one or more copies of this volume, at $10.00 each, you will assist all of us, who are giving our services without compensation, in doing a fine thing. The book will regularly sell for $12.50. It will contain 30 reproductions of Weston's finest work, which is probably the finest photography in the world today. It will contain articles on Weston by eminent painters, writers and critics who regard him as one of the most significant American artists.

One of the most distinguished New York publishers will handle and distribute the volume. The work of Weston will be reproduced full size, on the finest paper. It will be designed and bound in the best traditions of bookmaking, and all those concerned with its manufacture will aim to make it one of the finest books, as a book, produced in this country. Those who subscribe and send their check in advance, will, as one who assisted in making the book possible, receive their book especially dedicated to them. Regardless of conditions of which we are all aware, we believe this is one of the exceptional things which warrants our support. Checks should be made out to L. R. Kistler, Treasurer.

Sincerely,

Merle Armitage

Announcement: *The Art of Edward Weston*, 1932, Willard Van Dyke Archive

do some new work. Maybe later, if you can get away I'll buy gas and beans (should be reversed!) with Redwood League money.

By the way don't order a book, nor any of your "family" because they are going to give me a number to handle here, and I will save you a (or my) commission.

Love to you and Mary J. —

Greetings all around,

Edward

[Enclosure: reproduction of *Point Lobos*, 1930 with notations: "printer: watch middle tone values." On back a note to Van Dyke in Weston's handwriting, "using better paper than this — ." In *The Art of Edward Weston* this plate is titled, *Eroded Rock No. 50, 1930.*]

Letter 13 27 January 1933
Carmel, California

Dear Willard —

The *f*/64 exhibition, shows up well at "Denny Watrous." They wish to give us another (free) week, O.K.?[16]

I don't want to hold back the group from a New York show on my account, but I really feel that it would be a bad move or gesture for me to make this year. First of all, I have already turned down the "Delphic" this year, and there are a number of angles to this refusal, too complicated to write about. I don't want to get in bad. If I did send, my prints would be an old story to N.Y., — for I wish to save anything new.

Apart from my participation; — don't you think the group a bit hasty in wanting to show this year? Frankly I think it would be premature. Between you and me, I think some of the work — seeing it again down here — quite unimportant. I want to discuss this with you when we meet; — in <u>private</u> —

I liked <u>one</u> of Henry [Swift]'s "abstractions" <u>very</u> <u>much</u>; the others not completely realized. "The Carmelite" has gone out of business, so no publicity, but a lot of interest.

I will keep in mind what you say about some Monday. I would like to come up. I don't know

when. Much depends on the outcome of the "Venus" case in which Neil is involved. Think I wrote you about it.[17]

My sister just sent me several of my first "serious" photographs, done at the age of 16! At least I tried to make them sharp!

Love to you and M.J. — and hopes — that you are working well —

Edward

Letter 14 7 February 1933
Carmel, California

Dear Willard,

Your second wire was as much a disappointment as the first was an occasion for joy. I hope the car trouble proved no great expense. Shore was with us when your message came, and beamed with anticipation.

I see no immediate prospect of going north. Finances pretty low, (despite the myth of my $1000.00 sitting which Consuela [Kanaga] told a friend of mine)! — how do such stories originate! I wish it were true; I would close for a month. On the contrary I'm faced with extra expense in the form of lawyer's fees for the "Venus" case!

I was much interested in your experiments with P.O.P. [printing-out paper] There is no question that it has quality. I would not be astonished if you found in it a longer scale than in chloride. I do not think Palladiotype is made in glossy. Willis & Clements used to list a semi-gloss Platinotype but discontinued it.

I forgot to tell the printer that I used my stationery horizontal; which seems best for one who writes speedily and spreads all over the page! So this job is a mistake.[18]

I hope your misadventure will not discourage you in coming soon.

All good wishes and love to you and Mary J.,

Edward

Equipment list for

An automatic Flight of Tin Birds

3 rolls Panch Supersensitive film @ 5⁰⁰ 15⁰⁰
Graflex camera (Van Dyke)
Movie tripod (H. Swift)
Movie Camera (H. Swift)
Exposure meter (H. Swift)

Blackboard for titles

2 photoflood bulbs @ .35 .70

Reflectors (Imogen)

Filter K1 (get from Wilton Co)
Filter K2 (Van Dyke

Film script: *Automatic Flight of Tin Birds*, 1933, Willard Van Dyke Archive

Letter 15 **20 February 1933**
Carmel, California

Dear Willard —

You have much interesting news! — exhibits at de Young, "An Automatic Flight,[19] etc.," *P.O.P.* (be sure to bring comparative experiments), and new negatives.

So have I. I am chairman of photo-section of "The Foundation of Western Art", L.A.,[20] with power of an absolute dictator, a one-man jury; the only condition under which I would accept! This may mean my resigning from *f*/64, for I expect to select most of first exhibit from *f*/64, and don't want accusations of "politics". More later. Keep this to yourself.

I have some new 8 x 10 negs to show, and some new 4 x 5 portraits! Want to do you and M. J. for my new collection.[21] It's great to be working again.

Has Shore written you? She was very happy, and wants you to select a lithograph, — anything but seals, which is nearly exhausted.

Expect you on 27th in time for supper!

Love to you & M. J.,

Edward

Bring your 8 x 10 this time! Great stuff at lighthouse.

Letter 16 2 March 1933
Carmel, California

Dear Willard —

We were disappointed when your card came; were kind of ready for a few days photo-debauch. The weather has been marvellous — sun-baths on the beach, etc.

I don't expect to go south — if at all — for some weeks. The girl who wants to line up the sittings, has "cold feet" because of my "unretouched portraits". I may be up looking for a job in your gas station!

If you plan to come next Monday, let me know in time, because Shore has been after us to go with her to Santa Cruz where she drives every Monday. We have refused, fearing to miss you. Of course we would be back by 6:00 anyway.

When you do come, bring the "E.W." book.[22] I want to write in it.

Have you read "Lady Chatterley's Lover"? It's a great book. I have a copy here; Merle's.[23] Have been working well, and have had two swell adventures!

Love to you —

Edward

Edward Weston
Mary Jeannette Edwards, 1933
Edward Weston Archive

Letter 17 8 April 1933
Carmel, California

Willard —

A word to say that I will mail our exhibit Special Delivery Monday. I had hoped to send today, but have had a hectic week (not what you think). In the midst of printing Hill order and exhibit, the bank phones that I had overdrawn $50.00. My books showed a balance of $50.00. It was adding machine against my "brains", the machine won! I found that in Feb. I had added $100.00 to my acct. instead of subtracting. But the gods were kind; the same day I received two old checks, almost despaired of. So I covered my delinquencies, and we are eating, albeit discreetly.

Glad you like proofs; will finish <u>all</u> that you marked, given time —

As to *f*/64 exhibits in east (outside N.Y.) — go ahead. I can't get very enthusiastic. Guess I'm fed up on exhibiting —

I enclose an extra copy of "Willow" for Lloyd [Rollins]. My exhibit, to you, should be titled "Spring is here, tra-la-la!" What a shame that Mary J.'s negatives were fogged. Back loose? I got some good things, romantic (pictorial) period.

Love to you both — and wishes for a successful exhibit,

Edward

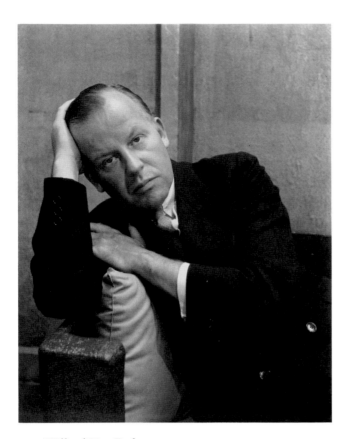

Willard Van Dyke
Lloyd Rollins at 683, 1934
Made from negative in the
 Willard Van Dyke Archive

have others as good as in the bank. We have friends who drive up each weekend, and may take advantage of the chance to see you and the exhibit —

E —

Letter 19 24 April 1933
Carmel, California

Dear Willard —

Is it <u>true</u> about Ansel, Virginia, and triplets!? What a man! — or maybe I should say what a woman![25]

I have checks in which clear my way to Taos — Mabel [Dodge Luhan] tells me that April & May are bad months, high winds & dust storms. Could you leave in June, around the first? Mabel leaves Wednesday.[26] Again, she welcomed us.

I may have a chance to drive north this weekend. Could you drive back the first of next week with us? I can now get good <u>vino</u> here. We will spring a party for the Mexican Consulate.

Expect to leave for Los Angeles in about two weeks or so —

Love to you & M.J.

Edward

[Notes on envelope in Van Dyke's handwriting: "May 10th-24th / Wengenroth / June 15th-July 1st / Lavenson / ⋆Retrospective / Rotan / Evans, Walker / Edward Retrospect. / Imogen, Edward, Ansel, J. P., Willard"]

Letter 18 21 April 1933
Carmel, California

Dear Willard —

Thanks for catching my mistakes. I had not intended to be "original." Here is a corrected version.

The news about Lloyd has sickened me.[24] The sexually unemployed are still strong enough to wield the big stick.

Interesting comment on my nudes. I thought they would be received with great enthusiasm! But I should have known better —

I have not given up the Taos trip. Hope you have not. But I cannot plan until certain checks come in. I just received one, "no funds"! Well, I

Letter 20 7 June 1933
Carmel, California

Dear Willard —

Wire at hand. Date of leaving suits me.[27] What think you; shall we stop over at Arensbergs on the way?[28] The return is always more hurried. I think you will not regret the contact, nor what you will see! Then we could buy our groceries in L.A. at considerable saving. Let me know <u>your</u> wishes —

because the contact is for you — by return mail, so I may wire Arensbergs to hold Tuesday open.

Will Mary J. come with you to stay awhile in Carmel? The place and everything in it will be hers. Chan and Teddie will be here — the latter good as gold — and Neil, unless he goes south.[29]

I just ordered a case of 8 x 10 and of 4 x 5 film, — plenty for both of us —

The Jeffers will be in Taos while we are there —[30]

Love —

Edward

Letter 21 8 July 1933
Carmel, California

Dear Willard —

Your letter saddened me; that part concerning Mary J. It seemed like the end of something very beautiful, — you two driving down together, surprising us — yet I know that when a chapter is finished, a new one starts — and I know that you both have the guts to assert your wills, — eventually.

The refusal of "security" through marriage was to be expected. I remember a previous refusal of "security" which I shared in.[31]

What a shame you had fog! — that is tough. I had one fogged, but don't think I have a leak; probably a holder not well inserted. The transparent spots on my films are not from uneven development, nor are they air bubbles. I'll have to show you. The g.g. [ground glass] image with my single element appeared sharp enough; I have been wondering if the visual and chemical focus do not coincide. However the negatives are in no sense "soft"; only not as "biting" as an anastigmat. The shorter of the two elements seems sharp as doublet. How about the print I was to spot? I do hope you got some negatives from the trip you are happy with.

Date for exhibit O.K.[32] But I will have to get busy at once. Have prints to get off for Gurlitt too. And Chicago,[33] before I know it! How many invitations will you send out? Considering the little prints for announcements — I am wondering just how advisable it would be to use them — Those who know my work, and care for it, will be intrigued enough by the "30 Years of Photography" (actually 31); those who do not know it, may not catch the significance in seeing a print 31 yrs. old, may not bother to come, after seeing it.

I realize that I am "hedging" a bit on account of the labor involved, — no, not the actual work for I will go to any length to make this show a success, but the short time within which I must copy and print. Tourists are in town and I have to wait like a spider for its prey! What think you?

I just remailed a letter from your little sister [Mary Carolyn Van Dyke] to Neil who is in S. [Santa] Barbara. I hope her influence will improve his capacity for correspondence. Next to Chan, he's the world's worst correspondent! I like very much this mutual attraction, — "in the family." Neil has never before shown any interest in girls.

We must go back to those California Hills and the old passenger-cars (Merle tells me there are old engines too) seen on our last lap homeward bound. The light will not be at its best for many more weeks.

I suppose you have talked with Ansel re the school, etc. I have not heard from him again.

Maybe Neil and I can come up for my exhibit. I promised him. But no bed! You still have couches, and a floor?

All love to you — to Mary J.,

Edward

Letter 22 14 July 1933
Carmel, California

Dear Willard

The announcement O.K. except that my first prints are dated 1902 which makes the elapsed time 31 yrs. But maybe 30 years sounds better? Do as you wish —

If you do come down next week, I will try to have the exhibit ready for you to take back. Otherwise I will probably ship express account of nudes. To what address? Of course I trust you to hang it! I want to be with you for the opening. All will depend on "business" and my economic condition at the time.

"683 BROCKHURST"

OAKLAND·CALIFORNIA

A GALLERY DEVOTED
TO CONTEMPORARY
EXPRESSION IN
BLACK·AND·WHITE

This is the only exhibition I have ~~have~~ assembled
which dates from my first photographs done with definite
intention. Previous to the earliest work shown here--made in
1903 at the age of seventeen--I had used for a few months, a
small "box" camera, with which I acquired the rudiments of
technique and a desire to go ahead with more flexible tools
and materials.

With the exception of a period from 1906 to 1912--
not available--this exhibition is complete in progression.
It is presented to show the change of approach which can take
place during thirty years of growth,--and also the adaptability
of photography in meeting diverse needs at each new point of
departure.

I feel that my earliest work of 1903-- though im-
mature--is related more closely, both in technique and con-
ception, to my latest work than are several of the photographs
dating from 1913 to 1920; a period in which I was trying to
be "artistic".

July 1933

Edward Weston

WILLARD VAN DYKE AND MARY JEANNETTE EDWARDS

Exhibition statement: "683 Brockhurst" gallery, July 1933, Edward Weston Archive

Exhibition announcement
"683 Brockhurst" gallery
July 1933
Edward Weston Archive

Neil still in Santa B. (2 City Hall Plaza) with Brett, and not eating very well! If I do go north, will try to bring him too. Wanda & Mary C. [Van Dyke] are always welcome to the studio. Please tell them.

I hope this finds your father better — give him my kindest regards. Was it the "Pirmide del Sol" that he liked?

So glad you got that negative you like, on our trip. For me it was worth while too. I have about ten negatives that will go into my Chicago show, as being enough different from my other work to warrant their inclusion.

Fog almost every day since our return. It makes me think seriously of New Mexico.

Greetings & love to you and Mary J.,

Edward

Letter 23 18 July 1933
Carmel, California

Dear Willard —

Merle and Elise arrived the eve after your departure! I was not keyed for company! [Jean] Charlot is in L.A. He thought Carmel was a suburb of L.A.!

I am to have a one-man show in Chicago at "In-crease Robinson Gallery," one of finest, — coming September. So, to work! But first your show.

Address of: Dr. H. Gurlitt, Kunstverein in Hamburg, Hamburg 36. Neue Rabenstr. 25

Report on negs. Two from painted desert, — over exposed, as I knew after leaving, but printable — Church at Laguna, over exposed, because I gave "correct" filter time with filter off! But fortunately have one with filter, over corrected, — but I like it. All balance, correct exposure. Had one fogged? Several with dry scratches and several with irregular transparent spots which I have had before, and blamed emulsion, not knowing what else to blame! Those done with longest element, none too sharp; — lens? or my eyes? Looked sharp on g.g. [ground glass]!

Have you figured gas acct. yet? When is it due? Let me know. I want to pay at least ⅔ of everything.

It seems incredible, but I started with $35.00 cash and $20.00 check, and arrived in L.A. with about $1.00 left. I spent for personal needs $5.00 for Cristo — $1.00 Teddie huaraches, $1.00 Mexican napkins, $3.30 for cigarettes. In L.A. spent $11.00+ for auto repairs.

Now I must to work with a vengeance.

Always love to you both —

Edward

15

CLUB NOTES

Forthcoming Exhibitions

Barcelona Salon. October 1st to 31st. Address Secretario del Salon Internacional de Arte Fotografico, Agrapacion Fotografico de Catalune, Duque de la Victoria, 14, Pral; Barcelona. Closing date September 1st, 1933.

Fourth Irish Salon. October 28th to November 4th, 1933. Address the Honorable Secretary, Irish Salon of Photography, 18 Morehampton Road, Dublin, Ireland. Closing date September 30th, 1933.

Rotherham Photo. Soc., 44th Annual Exhibition. Oct. 18th to Oct. 21st, 1933. Address Mr. E. George Alderman, "Ruardean", Newton St., Rotherham, England. Closing date Oct. 2nd.

Los Angeles, 17th International Salon. Dec. 31, 1933 to Jan. 28, 1934. Address, Camera Pictorialists of Los Angeles, Los Angeles Museum, Exposition Park, Los Angeles, Calif. Entry fee $1.00. Closing date Nov. 1, 1933.

Wilmington Salon, Jan. 8, 1934 to Jan. 28, 1934. Address E. W. Sautter, Sec. Salon Com., P. O. Box 818, Wilmington, Del. Entry fee $1.00, limited to four prints. Closing date Dec. 1, 1933.

Madrid Salon. Address Senor Secretario de la Sociedad Fotografica de Madrid, Calle del Principe, 16, Madrid, Spain. Entry fee 12 pesastas. Closing date Dec. 5th, 1933.

Antwerp, 7th International Christmas Salon. Dec. 24, 1933 to Jan. 7th, 1934. Send entry form with 5 Belga entry fee to Mr. J. Van Dyck, Sec. Fotografische kring, Iris, Ballaer str., 69 Antwerp, Belgium. Send prints to Mr. Em. Borrenbergen, Dambrugge-straat, 265, Antwerp, Belgium. Must be mailed on or before Nov. 15th.

"683 Brockhurst"

The remainder of the above address, which does double duty as a name as well, is Oakland, Calif. This charming little studio and gallery is now under the direction of Miss Mary Jeannette Edwards, and Mr. Willard Van Dyke, two young people with a splendid enthusiasm for photography. Miss Edwards writes: "For a long time we have felt that the Pacific Coast is a particularly fertile field in its photographic activities; that here are many of the finest photographers, and that their work should be shown. "683 Brockhurst" seems to fill the need for a suitable gallery, not only for the showing of exhibits, but for a discussion center as well. We hope that all who are interested will consider it as such."

From July 23rd through Aug. 12th the gallery held an exhibition of the work of Edward Weston, from 1903 to 1933. The prints were arranged chronologically affording an interesting opportunity to follow the evolution of this artist's work. We were struck by the fact that some of Mr. Weston's latest things were not of the close-up type for which he is famous, but might almost be classified as landscapes. Landscapes have been something of a bugaboo to the "new photography" and it will be exciting to see what Mr. Weston can do with this problem.

From Aug. 15th through Aug. 31st there will be a showing of the lithographs of Adolph Dehn. Mr. Dehn's work is noted for his satirical comment on contemporary life, and is said to carry on the grand tradition of Daumier and Hogarth.

On September 1st a group of 25 prints by Ansel Adams will be hung. A resident of San Francisco Mr. Adams is well known for his sympathetic photographs of this city and for his splendid prints of the high Sierras.

For the future one man shows by Willard Van Dyck, Imogen Cunningham, and others are planned. Visiting hours are from 2 to 5 in the afternoon.

American Photographic Society

Progress is slow but steady in the formation of the American Photographic Society. Each step forward, however brings

Article in *Camera Craft* magazine, September 1933

Letter 24 **31 July 1933**
Carmel, California

Dear Willard —

Heard through Wanda that the show is going over well. Fine! I think you should have a <u>show-case</u>, perhaps outside by the door, so that <u>all visitors</u> will be <u>compelled</u> to <u>see</u> your <u>work</u> or M.J.'s — In this way you will reap some benefit.

Wanda and Mary C. have become part of the family to us — I hope, and believe, they feel at home. Today they move over to studio.

Mary B.[Gray Barnett] called Sat. and Sun. I was printing both days so didn't see her. Wish she had called me first. I would have been at studio to greet her.

Have you received gas account? Better send soon as can — while the tourist season is on! I had a <u>real</u> sitting Friday; a rare bird —

Jean Charlot arrives Saturday. Will speak on Mex- contemporary painting Sun. at opening of his exhibition. I felt deeply your state of mind, while was with you last. But I know so well that no one can do more than give understanding sympathy to another.

<div align="center">Love to you, and Mary —

Edward</div>

If you have extra announcement send to Henry Ohloff / 246 2nd St. San Francisco / important —

Willard Van Dyke,
Mary [Gray Barnett], 1934.
Made from negative in the
 Willard Van Dyke Archive

Letter 25 **8 August 1933**
[no return address]

Dear Edward:

I should have written to you before, but I have been working ten hours each day for six days per week. When one sleeps nine hours, there is little time left for anything else. I am sure this sort of thing will soon be ended. Hurray for NRA [National Recovery Administration].

There have been many people to see the exhibit. It is by far the biggest success we have had. There have been many amusing incidents connected with it. Some people have been horrified, some ecstatic, few apathetic. The new editor of Camera Craft was in; [Sigismund] Blumann is no longer with the publication. He seemed interested in the gallery and is going to give us a write-up.[34]

Ansel is back for two weeks to get his gallery started. Virginia bore him a baby boy at Yosemite while Ansel was away on a hiking trip with the Sierra Club. He says it was all very easy — for him. Don't forget the five prints for Sept. 1st. Sonya too.[35]

Stieglitz got the announcement of your exhibit. He told Ansel so in a recent letter. It was forwarded to Lake George.

I am very glad my sisters could have this contact with you and your family. It will mean much to them, especially to Mary Carolyn. You are very kind to take them into the family this way. I am glad M.C. can observe the peace and happiness possible without the unnecessary luxuries of life.

Letter from Willard Van Dyke to Edward Weston, August 8, 1933, Edward Weston Archive

I hope to be able to bring the exhibit to Carmel when it is through. Perhaps I can come down about the 23rd. I may go to San Diego next week for several reasons; to the *f*/64 exhibit,[36] to see M.G.B. at Ramona, to see Lloyd in Los Angeles, and if possible to take the Arensbergs to dinner in return for their fine hospitality to us. It is unlikely that I shall be able to go, but I am hoping.

The girls tell me the tourist season is keeping you busy — I'm glad. Let's hope you make enough so that you won't have to work all winter!

Love to all,

Willard

Letter 26 **15 August 1933**
Carmel, California

Dear Willard —

I snatch a moment to write a line. Charlot and Zohmah still here — I do hope you can get down before he leaves. He may go to S. F., — but not sure. I want to have Charlot see your work, and you his exhibit. It would be a grand show for your "gallery"; 6 x 8 oils. I have said nothing. Want you to meet first. But feel it could be arranged if you want it. Jean wants to show in S. F. probably first; that should not harm your showing.

Your letters and Mary's (this letter to her too) re exhibit, much appreciated — I hope it has meant

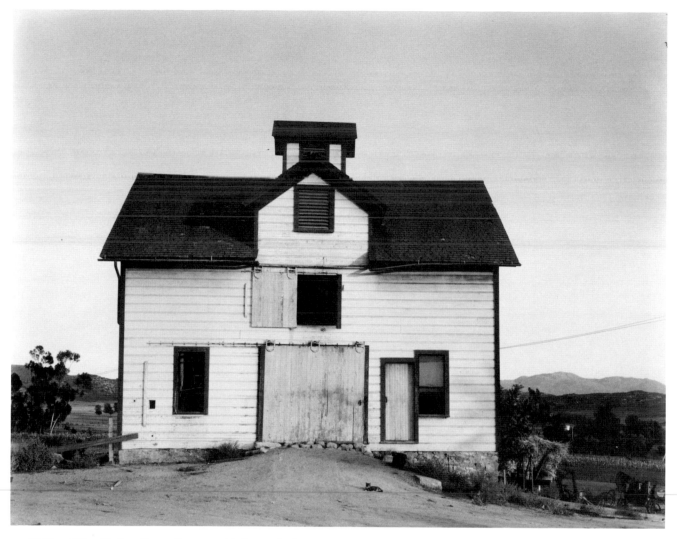

Willard Van Dyke: *Barn, Ramona*, 1933, made from negative in the Willard Van Dyke Archive

something more than pleasure to you! It is most gratifying to me that "people from all walks of life" find interest in my work. I have noted this, before Mary wrote to me. Of course I do not expect, nor want, it to become universally popular.

I am so glad the girls, Mary C. & Wanda had a good time — we enjoyed them —

Even this hurried scrawl is stolen from time which I must give to the Chicago show of 100 prints. I am making Jean select it. Much fun, though I may change some of his selections. You should see his drawings of Shore in her book!![37]

Much love to you both,

Edward

Letter 27 8 September 1933

[no return address; postmark is Oakland, California]

Thursday

Dear Edward,

I spent three hours at Ansel's gallery yesterday. I talked to him a long time about all of the work. You'd be surprised at the results of this show. John Paul has started to work again. He feels that his technic [*sic*] and his apparatus are insufficient. Henry Swift has been in almost every day talking

19

technic. He is getting a mercury vapor tube and re-modeling his enlarger. Imogen [Cunningham] is discouraged. I really feel that this show will have far reaching results. Everyone agrees that Sonya's things are superb. Ansel and I think she is the best woman photographer in America. There is only one fault to find with her work; I think she over prints at times. In the print of the ovens, the essential form, and planes of the wall behind them is lost in meaningless black. Detailess [sic] shadow is o.k. if it doesn't obscure necessary forms. The tree fragment is perhaps too contrasty, but the little tree at Taos is lovely, and very well done. I'd like to talk to you about the nudes someday. They mean a great deal to me, but there are certain problems involved which I'm not too sure about.

My own work is not what I feel it should be, but I'm still working and it is good to work.

I seem to feel that Ansel will always talk better than he will create.

Consuela Kanaga's things can only be considered in the light of moving human documents.

In other words: none of us is perfect, but the group is a live functioning thing. I hope it can continue.

There is an amusing story around that Charlot fainted during the operation! Did he tell you?

Much love, and in a big rush,

Willard

[notes on envelope in Weston's handwriting: "apologetic / not ans — will soon / Joseph Freeman / EW book"]

Letter 28 [ca. 8 September 1933]
[no return address]

Dear Willard —

A long [letter] from Ansel and then yours came today. Glad to know of the stimulus resulting from the exhibition. Ansel showed you, I guess, my letter of resignation — I have reconsidered, and told him to destroy it. Let's see how things go.

Sonya was moved by your remarks re her work. I would not have told her, but know she has a level head. She apologizes for not answering your question about Joseph Freeman.[38] We have both been pretty low as a reaction to last few weeks. I

have a bloody cold, — literally! Should be in bed, or jail.

The "E.W." book I sent you belongs to a girl (old flame) down south. If you have a chance for sale, let me send you a fresh copy, and bring hers with you next visit.

You are right in your comments on over-printing. I don't remember the particular print of Sonya's. Was in too much of a daze from printing, spotting, etc. 100, that I didn't see any of her new prints, — not really see them. She has a show of 40 on here. Over-printing may be my influence. I tend that way, and it can be destructive.

I wanted Jean to see more of your work; intended to bring some back with me — But forgot to! Had more on my mind than you can imagine, — or maybe you can! But Jean liked very much the ones he saw, as I told you. He may be up again.

I think Ansel misunderstood my reason for resigning, — at least my given reason —

Come down some time and we'll discuss the nude problem, — from human as well as aesthetic angles!

No, we never can reach perfection. Isn't that fortunate!

Love always to you and to Mary —

Edward

My Chicago announcement didn't please me, nor Jean. Too many, trying to work 400 miles apart; and no time to see proof. Too bad —[39]

Letter 29 2 October 1933
Carmel, California

Dear Willard —

Just finished "Look Homeward Angel." A magnificent work! It haunts me — some lines keep singing in my thoughts. I shall always connect you with this book; after that day in Taos when you read to us.[40]

Not much news, — excepting continued interest in Chicago show, and fine press articles. I'm pretty well tied, with Teddy to care for.[41] But, don't mention this "tied" feeling (or actuality) I have. It has to be for the time.

Love always to you & Mary,

Edward

Letter 30 [ca. November 1933]
[no return address]

Dear Willard —

Hope you enjoyed the line in my "Examiner" write-up, "I just looked up"![42]

I have been teasing Sonya all day about being a born artist, etc. via Oakland Tribune.[43]

But wait till you read the press from Portland! All about the "Weston Group"![44] I think I'll stay away from S. F. for awhile — can't face the music. I'm through as an impresario.

Next time Alma Reed gives me an opportunity to write her, sends me the promised check which will re-open negotiations, I will bring your work into the scene — tell her she "should be first, etc."

French annual: Arts et Metiers Graphiques
 18, Rue Sequier, Paris

I am not so enthused over f/64 show, Spokane, — or any other show. I have a one-man show in Stockton Museum, Jan.,[45] and my N.Y. show in March. I'm pretty well fed up! In fact swore that I was through for awhile. Anyway the Portland press-notices turned me against group-shows, even though I got the best of the bargain, — or for that very reason; I feel that I should get out of the picture.

[Albert] Jourdan[46] will send you all press-notices, he writes. Sent me photographs. Prints are well hung — though skyed — and in a good looking room.

That recent print of yours, — very fine. Hope you will get down this way to do more as good!

 Love always to you and Mary,

 Edward

Letter 31 28 December 1933
Carmel, California

Dear Willard,

I got to thinking this morning that I should have phoned you again last eve that we couldn't make it. I hope you didn't wait up. Brett had to drive the car back last night; it was borrowed. Today is his last day here, so I decided to stay with him; we promised him a party. But I was sorely tempted. It has been too long since we have been together! The

man, 84, — my sitting "took sick;" I got a wire fifteen minutes before the bus left on which I was going to S. F.! Almost wish I had missed the wire.

I am through with arranging exhibits, inviting my friends or enemies to show with me — It's the old story. I am fed up. Not to excuse Jourdan — or the [Portland Art] museum — it is most unusual to have prints returned in anywhere near good condition. Even my prints from de Young, under Lloyd were badly handled. I would write a protest. I will, — always do. It's the only way to get some respect for photography.

New Mexico and Arizona sounds too wonderful. I do hope for you!

I may yet go north for that sitting; in which case I will stay over for a good visit. But in the mean time, don't miss a chance to come down if you can —

Much to discuss. See "Thunder Over Mexico",[47] for the sake of discussion. I feel there has been to[o] much "thunder" over it. I left "let down." Expected too much. May have been badly cut. But also the technique, not so hot. Double printing very bad, confusing, — in "Cavalcade" it was better.[48] There were a few superb shots, but that is not enough. The "story," ordinary, in places melodramatic, almost on a par with some of our wildwest pictures.

Shan Kar dancers worth seeing.

 More soon —

 With love and greetings to you and Mary —

 Edward

Charlot's book, superb
Is it a hard and fast rule that all prints for the "Mills" show must be matted? I'm afraid that leaves me out.

Letter 32 10 January 1934
[no return address]

Dear Willard —

I hope you wrote a protest to Jourdan. I am going to, today. Our prints were badly treated.

Re the Mills College exhibition:[49] — unless I "land" a wealthy pupil today, I may leave for Los Angeles any moment, — in which case I will take all my recent work with me, hoping for sales. I just

cancelled my N.Y. show date. Told Alma Reed that I could not afford the luxury of a N.Y. exhibition this year.[50] I wonder how Ansel fared, and reacted.[51] I also wonder if the "Delphic" is the best bet for your first presentation.

By the way, when you first mentioned Mills, you asked me to write Brett to be ready. Up to the time he came here, he had not heard anything further. I have his prints here. What shall I do? Return them?

Nacho Bravo wants a second-hand dry-mounting press.[52] I thought of you?

Tell Wanda not to bother writing "American Forests." I got the dope. I did not receive even an

H. M. [Honorable Mention]! — nor did any Californian. "In the Path of the Storm" won. I can imagine what it's like. But I did want some of their money.[53]

The week before Xmas I sat here with "folded hands" contemplating at least 200 prints consigned to the discard, or extra pile. Old printings, old mountings, cracked, scratched and damaged prints. I took most of them to the Denny-W. Gallery, marked them $2.00 each, and sold $106.00 (my share) Xmas week. This saved the day. I have not had a sitting since November. I seem to be marking time here. Through?

I have had but one short note from Chan since he left here. This "not knowing" depresses me. I think Wanda fortunate that he left —

I have not read "Alice B. Toklas;" but intend to.[54]

Since you can't get down, I will have to go north. I am getting very restless. Maybe I can after my L.A. adventure. I may try another sale in the south of the remaining "extras."

I have been working well, — the best portraits and nudes I have ever done;[55] but I am chafing, nevertheless, at my confinement. Re my portraits, Consuela tells me that Dorothea [Lange] said they were so sharp they made her cross-eyed! I am complimented.

This is a long letter for me; it carries my love —

Edward.

Letter from Willard Van Dyke to Edward Weston
ca. January 1934
Edward Weston Archive

Letter 33 [ca. January 1934]
[no return address]

Friday

Dear Edward:

At last I've done it! Today I told the Shell Oil Co. that I was quitting — effective next Tuesday.

I haven't another job, I don't know how the rent will be paid, but I can't stand this any longer.

I'm wondering if you will be in Carmel next week, and if I might stay two or three days there.

I should like to see you, and as usual ask your advice.

With love,

Willard

Letter 34 **20 January 1934**
Carmel, California

Dear Willard —

When I heard of your new schedule at the station, I half expected that you would protest in some way.[56] So it has happened at last! Come down and we will break a bottle, — drink to the new horizons! New deal, or something — How about Wednesday? I am through with my pupil by then. Stay as long as you wish, or can; then we may drive back with you. Bring your camera! I'm on the P.W.A.[57] and have to "deliver the goods" each week. But I can do practically anything I want to!

We are all quite stunned by this mornings news. Sybil [Sibyl Anikeeff]'s sister — I don't recall whether or no you met her — committed suicide; she jumped from the eighth floor of her apartment in Shanghai with a son under each arm. All were killed. She was very close to Sybil, as were her children. Only a few months ago we had a gay party together, here in Carmel.

I have tried the Plasmat on my 8 x 10. It has very beautiful quality. Much to talk about. I'm sure you have too.

<div align="center">Love always, & to Mary.</div>

<div align="center">Edward —</div>

Letter 35 **[enclosure dated 1 February 1934]**
[no return address]

Dear Willard —

Home again, and pretty tired. Had to rush because Merle needed the prints to take with him to Washington. I suppose you have been through the same thing?[58]

I am glad though, that I went South — There, I got the spirit of the project, it's significance. It was all very exciting, "inspiring." Not that everything was good, but a number of fine things have been done, and the enthusiasm high — I think it marks the beginning of a new epoch in American approach to art.

I have to make at least 400 negatives. This is a pretty big job for one man to handle unless they let me go ahead at a slower pace. How many photographers are on the job in the Bay Region? For how many negatives, approximately? How much pay do you get? (Mine is now $38.25). And what are you allowed in materials? I think this exchange of data should be confidential on both sides.

I am leaving again about the 11th for another session. How about your show? I have gathered together another 100 prints for our "sale". No hurry on my part. Whenever you are ready.

Enclosed letter may interest & relieve you. Have you complained?

<div align="center">Love to you & Mary —</div>

<div align="center">Edward</div>

[Enclosure: Letter from Defender Photo Supply Company Inc. to Weston regarding cinch marks on XF Panchromatic film]

Letter 36 **5 February 1934**
Carmel, California

Dear Willard —

Negatives made with new meter are fine, with exception of Wisteria; it could have had 3X as much! Working close, with bellows way out — even when using doublet — increases exposure enormously.

I checked my pyro formula with Defender. I am using more sulphite★. Also use monohydrated carbonate which is 15% less than formula. I believe you use "mono" too? If so, and you cut down 25% more, the lack of density in your dune negatives can be accounted for. Bright as were the dunes, they did not have the brilliance of that white-washed barn.

Photographed Gieseking[59] this morning. What a musician! He did not need a double key-board piano —

We feel chagrined — did not mention the lovely bowls Mary sent by you! You can tell her how pleased we were, and thank her. They are in constant use. So much happened during our expedition and after arriving in S. F. we "clean forgot."

Have not heard from Stockton. Will wait a couple of days, then write for the prints. Found a few more here that came back from tree contest.

Edward Weston
Walter Gieseking, 1934
Edward Weston Archive

Walter Gieseking
c/o. Baldwin Piano Co.
20 E. 54ᵗʰ Str.
New York City—

Business card from Walter Gieseking
to Edward Weston
March 31, 1934
Edward Weston Archive

Exhibition announcement: "683 Brockhurst" gallery,

Thanks to you and Mary for a good time. I return stimulated.

Love,

Edward

*perhaps more than I need for Defender —

[note in Weston's handwriting on back of envelope: "Prints back from Stockton — can send up with Kathleen J. a week from Wednesday?]

Letter 37 **16 March 1934**
Los Angeles, California

Dear Willard —

Greetings from a fellow-sufferer! Or maybe there is no reason for your rushing now. Make your job last! I have to rush while here; but I'll make up in Carmel. Expect to be here until after the 24th, "our" birthday. I have never celebrated with Teddie. Yesterday I copied 24 large canvases in three hrs. and a half; about 8 min. to a canvas.[60] I had to walk the length of three long galleries for each painting. You see I need sympathy from one who knows!

The exhibition of P.W.A.P. [Public Works of

July 1934, Edward Weston Archive

Art Project] work drew 33,000 Sunday.

Glad you didn't dislike (at least) the write-up. I was not so sure — Awful rush, etc. Will get you copies when I return. Save Argonaut until we meet. Wonder how sale went. Keep prints as long as you think best.

You don't owe me a <u>cent</u> — I still owe you for gas, New Mexico!

And now to work —

Love to you and to Mary —
and all luck in the work —

Edward

Bought a tank —
Chan develop at night — [61]
Some help — Will print in Carmel —

Have gossip through Merle of Washington conference —

Letter 38 **31 March 1934**
Carmel, California

Dear Willard —

Home again, — and for good. I resigned. Work got too much for me; and too far away from my own "business." Chan stepped into my shoes. Did I tell you that Brett is on as a sculptor? He's happy, and got a raise.

Liked your announcement — "Pure Photography"[62] — whatever that is. Mine has been so im-

Article in *Camera Craft* magazine
March 1934

pure! I thought you were stressing the beginners angle? Will try to think up names.

Wish we could all get together. Much to discuss. I suppose you are very busy. Would like to go north. When, I can't say.

Love to you & Mary

Until soon, I hope — Edward

Letter 39 [1934?]
[no return address]

Dear Willard —

At last data on Mexico trip, from Enrique [Jackson] — he leaves Nov. 1st for six weeks. Gas and oil from here to Mexico City, 40.00, — in a Chrysler. Extra expense, $2.50 for bond on car at border, and identification card $1.00 per person. Trip takes six days, averaging 450 miles per day! From Laredo [Texas] to Mexico City 1½ days. Road good all way. Rain over by Sept. Exchange 3½ pesos to dollar. Need six tires in good condition. On account of exchange living cheaper there than here. Possible to get rooms for $10.00 a month.

Would you go regardless of my decision? I ask, because I don't want to plan, and then disappoint you. I will plan, want to go, but besides the economic question, enters always the family; — numerous angles I have not touched on. Don't think I'm backing out, but I would hate to be a wet-blanket at the last moment.

Merle and gang were loud in praise of the hospitality extended them by you and Mary. Kistler raved on and on about Mary. Your ears should have burned Mary!

Wish I might see the Pure Salon. Hope I can get up for "our" show. Will try to. Send down nudes if anyone comes this way.

Brett just left after several days visit taking Neil. Brought to show a very fine new sculpture, and new photographs done with 8 x 10 — More later.

Love as ever to W & M — E.

Letter 40 20 August [1934?]
[no return address]

Dear Edward:

Enclosed you will find the money I borrowed from you yesterday. Thank you very much. It was a lifesaver.

I had a grand mad time. It was like the old days in 1930 and 1931. I'm sure it wasn't so pleasant for you tho. Joe is still beating his breast and wailing. The trip back to Santa Cruz was like a fugue with the recurrent theme of remorse chanted by Joe.

I hope you like [William] Saroyan. I feel sure that he will be heard from very definitely in the next few years. But more than that I think he is a great human being with much warmth and love for his fellow kind.

Your new things made a big impression on me. I hope that you can get the new lens you want and need. I will send you a list of protars if you are interested.

Please tell Sonya that I want to see the new things she has done. I'm sorry that we didn't have more time to ourselves, but sometime soon, I will come down alone and we can talk it all out. We didn't even touch the Craven subject.[63]

Club Notes

F:64 Group Offers Traveling Show

The F:64 Group has prepared a group of 60 prints uniformly mounted on 14x18" mounts that will be available for exhibition by Camera Clubs or like organizations throughout the country beginning Feb. 1st, 1935. The show will be sent only to those who have facilities for exhibiting them under glass. This show affords a very unusual opportunity to see a very representative collection of the work of the leaders of the "Pure Photography" movement, and consequently should be of great interest. The F:64 group includes in its membership such well known names as, Edward Weston, Ansel Adams, Willard Van Dyke, John Paul Edwards, Imogene Cunningham, Consuela Kanaga, and several others. Requests for the exhibitions should reach Mr. Willard Van Dyke 683 Brockhurst St., Oakland. Calif., not later than January 5th, 1935, as the schedule will be made up at that time.

DECEMBER, 1934 609

Article in *Camera Craft* magazine
December 1934

Brett's new things (sculpture) seem very beautiful. I should like to see them. Do you think he would like to have a showing of photographs and sculpture, or just photographs, at "683"? We should like to show a group sometime during September, if he feels so inclined. You might mention it when you write, or shall I?

Much, much, love to all of you Edward. I appreciate and enjoy your friendship more than I can tell you.

Willard

Letter 41 **15 September 1934**
16 Prospect Road, Piedmont, California

Dear Edward:

I am writing to you on my new stationery. I hope you like it.

Today I happened to see a copy of Modern Photography — 1934–35 at a bookstore. Have you gotten your copy as yet? If not you will be surprised and pleased to see the amazing improvement in the quality of reproduction. Your church at "E" Town is very fine. It is a stunning thing anyway. Ansel's and my things suffered little in the reproductions also. I am really happy with the book from that viewpoint, but most of the things lack "punch" and the editors seem to be intrigued with angles and tricks to the exclusion of much good work. I know, because Bill Simpson sent a number of prints which were superior to 80 per cent of the work printed. And so we can expect it to be until we have our own publication.[64]

And now we should be thinking about another Group *f*/64 show. Ours is back and for the first time in over a year the Group is not on the walls of some museum or gallery. Please let me know your views about whom we should ask to show with us next time. My idea of a list would include Ernest Knee, Luke Swank, Bill Simpson, Abbenseth, and Brett. What do you think. What shall we do about Henry and Imogen? Please keep this to yourself; I hope that Sonya has some new things which are not a repetition of you. And I wish to Christ that I would do some new things. Or shall we forget about the group for a while?

I hope you will like what I have said about Dorothea Lange in the Camera Craft which comes out of September 25th, and I hope that I have not overstated the thing in my enthusiasm for a new idea (to me).[65]

Please give my love to Sibyl when you see her and tell her to keep up the good work. I wish I could

27

make her believe me when I tell her how good I think she is — with Nacho and Sonya copying you and Knee a re-echo of Strand and Virginia and Donald dead who should be alive.[66] And with me it is the making of money. And I care little for money. I must work about fifteen hours these days, and little it is that I care whether or not I never photograph another Chinese jade or another Boucher or Largilliere. But the money comes in and I can't refuse it and all the time I know that it is the result of lucky breaks and I look at Oscar Maurer[67] and Arkatov and am humble. For I know that someday I too will perhaps be unlucky and will have to swallow what remnants of pride I may possess and ask some young squirt for a job. But I am not being maudlin or sentimental about all this I hope, only modest. With the knowledge that my mother gave me the instinct to know a valid thing was you, and your great work.

Very much love,

Willard

Letter 42 **[1935]**
[no return address]

Dear Edward:

Your good letter arrived this morning, and it was a great treat to hear from you after all this time. I'm glad you feel so well mentally and that things are beginning to pick up a bit financially for you. The place at the beach sounds swell.[68] Somehow you belong near the sea and the sand. I shall always see you so. Even with the warm memories of hours together at my studio.

I've about given up hope about Washington. I hardly think there is any chance of jobs coming through much before next year, from what Mrs. [Nina] Collier says, and probably things will have changed very much by then.[69]

So here I am in New York, for how long I don't know, but surely until October first, and probably until next year. My future is most indefinite. I am very happy here, and working very hard. I am a member of Nykino, a small group of enthusiastic people producing movies. [Paul] Strand and [Ralph] Steiner are also very active members — Strand only recently so.[70] He went to the Soviet Union with the hopes of working there, received a great deal of praise for his work especially from [Sergei] Eisenstein and [Alexander] Dovzhenko, but found out, as I did, that they are no longer relying on foreign talent or guidance, and it is very difficult to go there to stay unless one wishes to become a Russian citizen, and even then it is not so easy.[71] So here he is, and it is our gain. Anyway, we have ambitious plans for the future including full-length sound productions. More of that later.

In addition to this, I am taking a course in Play Analysis, and learning a very great deal. There is certainly a lot that I don't know. But here one could keep on learning indefinitely. There certainly is opportunity. I can't understand why New York was so distasteful to Ansel, and yet I say that knowing very well why it was.

And to make a living? Steiner has been more than swell to me, and I am now working with another friend of his, sharing the same apartment, working together. We do a lot of work for Harper's Bazaar, which you will see (if sometime you should see a copy in the next months) under the names of Nyphoto or Van Dyke-Trubov. Also we have a great deal of work from William Lescaze, the modern architect. So we will probably be able to make a living — in fact we are already doing that, and have a couple of dollars left over for making films. There is a lot of entertainment here, what with the plays, movies, beach, country on weekends and all the great wealth of color of the city. And I am forgetting my bourgeois need of a car, as we use the subway in the city and on the weekends we hitchhike out into the open country. We got back last night from a trip about 75 miles north, where we spent the weekend. In a couple of weeks we'll take a few days off and hitchhike up to Maine. It is rather an easy thing to do here. The only thing is that one usually has a lot of feminine competition. All of the young women who work in offices, spend their weekends that way if they haven't cars.

Stieglitz is out of town for the summer, so I haven't seen him, and of course all of the galleries are closed. But I told you that I saw [Julien] Levy before I went abroad. I will undoubtedly see more of him this Fall. And I will also see [Berenice] Abbott and [Thurman] Rotan and some of those people when I get around to it. So far I have been pretty busy getting adjusted.

And now it is three months that I have been celibate and sometimes I wonder vaguely what that

thing is that is hanging between my legs. Did I ever use it for anything except urination? It seems that once I did, but whether I would still know how to use it, is somewhat of an unanswered question. But surely that will be remedied soon. If I can ever find time to make the necessary contacts.

Please write when you feel that you can spare the time, and thanks for the kind invitation to visit there. Perhaps I will accept it if I come to Los Angeles in October. My ticket is via New Orleans, and unless I turn it in, I will be going home that way.

Please give my best to all of your sons. And to C.[Charis] when you write. And much love to you, Edward, I shall be happy when I look into your warm brown eyes and embrace you.

Willard

P.S. Steiner and Strand are going to do a dust-storm film for some department in Washington. I wonder — [72]

Letter 43 **[ca. April 1937]**
[no return address]

Dear Edward:

This isn't a letter, it is just a note. Later I will write more.

Some time ago, in fact before I went to Europe, Al Young [George Allen Young] of Camera Craft spoke to me about publishing a book of straight photography and asked me to work with him on it. Now it seems that the time has come when he really is going to carry it through. It will reproduce the prints full size, with a border, on coated stock by the half tone method. There are to be five contributors, you, Ansel, Steiner, Walker Evans, and myself. I am wondering whether or not Al has spoken to you about it, and what you think. Everyone here is lined up for it. Will you let me know immediately whether or not you will let us have about ten prints from which we may choose six, or will you choose the six yourself?

If you will drop me a line here, in the enclosed envelope I shall appreciate it greatly.

A letter from Pres tells me he is working in Georgia as an archeologist, hopes to go to the University of Chicago this Fall, and eventually will be a Smithsonian archeologist. He is married you know.

Gretchen [Schoeninger] writes from the Pacific weekly.

Mary J. wrote me a long letter recently the greater part of which was about you and what you had meant and do mean in our lives. You really do, you know.

Much love to all of you.

Willard

Letter 44 **[ca. April 1937]**
[no return address]

Dear Edward:

Thanks for all of the letters and wires and things.

It all happened like this; a week ago Monday night I was about to leave for Hollywood, it was nine-thirty, my train left at eleven-thirty, I called Peter S. [Stackpole] to say goodbye, and he said that he had talked to the people at U.S. CAMERA that day, and they said that you were coming to New York to help on the judging of their book.[73] I then called Maloney at his home in Hoboken, and he said that he thought that was the case, and that you were expected in town that day. So naturally I cancelled my ticket. I thought that perhaps you were going to surprise me as I used to surprise you in Carmel. To see you here would have been too great a treat for me to miss. It was not until after receiving your wire that I found out I was wrong. Where the idea got around I don't know.

How glad I am about the Guggenheim, you can only imagine. I can't tell you what a fine sense of satisfaction it gave me that you should be the first photographer to receive one. It is only fitting and right, but often things don't happen that way.

My plans are now very nebulous, because the day after I was supposed to go, another job came up here, and until it is decided one way or another, I can't go West. But I shall be coming, and certainly before the middle of May.[74] Don't think about trying to put me up, I am relatively flush, at the moment, and I can easily put myself up at a small hotel. If there were any chance to go with you on a short trip, I should love to do it. But we will talk about

that later. At the moment I plan to go North first, and then come to Hollywood on my way back here. Unless I get a job doing some shots for [Pare] Lorentz in one of the studios there, that is the way it will be.

So until I get there, Edward, good luck to you, and much joy in the release that must have come with the knowledge of a free year.

Love,

Willard

P.S. I am going to see your show this afternoon. The things you and Brett sent to the Museum of Modern Art are badly hung and arranged, but very beautiful. I like in particular the light sand dune. It is a beautiful print. And Brett's emery dust on glass is amazing.[75]

Letter 45 [ca. April 1937]

[no return address]

Dear Edward:

I have no time for a letter, but I want to snatch a moment to report to you on the hanging of your show.

I am sorry to say that I feel the whole thing is very unfortunate. The prints were hung in a double row, not under glass, eighty of them in a small room, so tight and close there was no breathing. The light was bad, because it came from one globe in the center of the room and from two small high windows in the front. Personally I feel that the show lacked dignity — the sort of dignity your work deserves, and the hanging at the Museum of Modern Art of your work only made things worse. After all the two galleries are right across the street from each other, and so quite a few people who came to the Museum also went to your show, although the times I was there (three in all) the attendance at your show was not very good. I feel that a minimum amount of paid advertising is necessary.[76]

Let me tell you about Strand's prints at the Museum [of Modern Art]. There were thirteen of them across one wall. Each print was bound with glass and white, plain, passé partout. There was lots of light above them, and as a consequence the things had even more dignity and beauty than they would ordinarily possess because of the contrast with the rest of the show. I feel that if I were ever going to show in New York, I would insist on having my prints framed, or bound with passé partout.

As a final insult to your work, Nierendorf (who seems to be a nice guy, but who is living back in the age of Blossfeldt, and the Clavilux, and R.U.R.) had the price written on the mount in pencil in rather large figures in the lower right hand corner. To me that is inexcusable.

Sorry to have to give such a report, Edward. I know you will understand that I have such a strong feeling about your work, that I am angry when it is not treated as it deserves to be.

I felt the reproductions in LIFE were unfortunate, didn't you? I have written, or rather helped a friend write, a letter commending them on showing your work, deploring the lousy reproduction, the bad portrait, and the inaccurate reporting.[77]

Luck to you, and much love, Edward. I don't know how soon I can leave for the Coast, I am still shooting.

Love,

Willard

Letter 46 [ca. July 1937]

4915 Proctor Avenue, Oakland, California

Dear Edward:

When the phone rang, I said to myself, "That is Edward" and recalled how I had tried to reach you twice in the two days previously, with no success.[78] Mother went to the phone, and there was no one there, although the bell only rang three times. When I went to Mary Jeannette's she asked me if you had reached me.

I am very sorry I missed saying goodbye, Edwardo, because I am afraid I shall be back in New York before you return. I have no good reason to stay here, now that my work is finished, unless I can find other things to do now. I would do a series on you, and how you work, if we could go someplace together, and if that trip works out that we planned I will surely do it.

Today I have been going over a box of papers and letters that I should have sorted out many years back. Among them were some very early letters from you — early in our friendship — that gave me a

PICTURES TO THE EDITORS

Group F. 64 (*see letter, below left*) was founded by Willard Van Dyke as a revolt against the "art photograph." At the left is Mr. Van Dyke and his camera. Below are samples of his fine work.

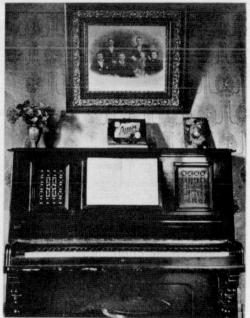

F. 64

Sirs:

The statement that Edward Weston founded "Group F. 64" is erroneous and the name "Group F.64" was chosen not for the reason LIFE states (LIFE, April 12). In 1933 Lloyd Rollins was director of the De Young Museum and the Palace of the Legion of Honor in San Francisco. Rollins was interested in photography and gave it a place in his exhibitions. Because of the interest engendered, a group of California photographers found that they had similar aims and worked in a similar way. Roughly this was to render the tonal gradations and the textural surfaces of their subject material in as realistic a way as possible. About this time, Willard Van Dyke, a one-time pupil of Edward Weston, opened a gallery in Oakland. Among the exhibitions was a large percentage of photography. Photographers who attended these and Rollins' shows, decided to hold a group showing. Van Dyke was responsible for the organization of the group, and for its name, Group F. 64, which was chosen not because its members were fond of using that stop, but because they found that smaller stops gave the greater depth of focus necessary to the clarity of their work.

MARTIN HARRIS

New York, N. Y.

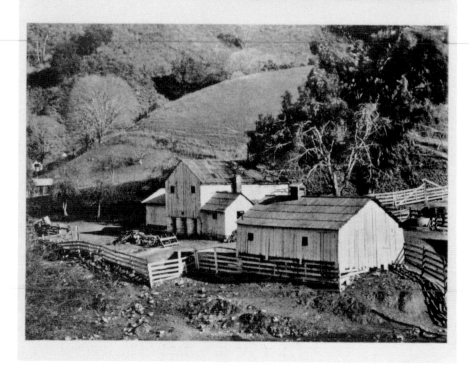

Letter published in *Life* magazine (May 3, 1937), page 87
Courtesy Life Picture Sales

swell feeling and at the same time a bad case of blues for all that I don't have anymore. There was something very wonderful about the Carmel days when Mary Jeannette and Pres and I were used to dropping in on you with a jug of wine. There were letters from you congratulating me on my first exhibit, urging me not to force myself — advice I sorely needed in those days, and letters answering wails of mine when the going got tough at the Service Station. They were and are good letters, Edward, and I know that I would not have the outlook on life I have now if you hadn't been so generous. Thank you for them and for being such a good friend. There aren't many of them in one's lifetime.

Please give my best regards to Ansel. I hope I can see him while I am here, but if he intends to be there all summer, I doubt it very much. I have never been to Yosemite, and I don't think this is the time for me to go — at least as a photographer. And much love to Charis, whom I got to know better this time than ever before.

<div style="text-align:center">With affectionate greetings,</div>

<div style="text-align:center">Willard</div>

[Note on back of this letter is in Weston's handwriting and is probably a draft of a telegram to Brett Weston: "Brett W., 1328 Greenwich, Arrive tomorrow night. Phone Willard immediately. Ansel's darkroom burned. Dad"][79]

Letter 47 **27 February 1938**
[no return address]

Dear Edward:

For so many months I have lost track of them I have been trying to find the time to sit down at a typewriter to send a few lines to you.

First of all, enclosed you will find the check that the magazine sent for your picture. It isn't nearly enough, but they felt that in view of the fact they were going to use several of the Group's pictures, they could only pay that much. I hope you will not be too hurt.[80]

I am sending by express the two packages for you — the film I promised and the pictures I did of you and the ones Life returned to me. I wonder if you could sometime send me a couple of real Westons so that I could frame one of them for my wall,

and present the other one to Ralph S.? He has expressed a wish for one, and I would like to make it possible for him to have it. You told me that you had done a picture similar to the one Brett did of the waterfront. If that is printed, I should like to have it for Ralph, and for me I would like a nude on the sand dune. Whichever one you like best. I think it would look well in the bedroom here. There is no hurry about it. Just sometime when you are printing.

I had planned to go to Egypt to make a series of films, but at the last moment that fell through, so now I am doing a picture for the New York World's Fair, and one that shows how to use a candid camera — especially a Zeiss candid camera. They are giving me a lot of equipment in exchange for the work, so if you want anything just let me know and I can get it for you at fifty percent of list price.

I hadn't meant to keep from you the fact that Mary [Barnett] and I are married. I just hadn't given it a great deal of thought. We were married on January second, a couple of days before she went to California for a visit. In view of the fact that I sometime want some children, it seemed a smart thing to do. Every time I think about what a lot of trouble the kids would be, I think of the four fine Weston boys, and it seems worthwhile. Only I'd hate to have four girls.

I'm glad you liked "The River". It has gotten swell reviews, and I think it is a pretty good film myself. I didn't do all of the photography, but a substantial part of it was mine.

I am no longer connected with Frontier Films, Ralph S. and I have formed a corporation to produce educational and instructional films — any films "in the public interest".[81]

We are associated with a group of men here who are doing publicity for foundations and universities, and they furnish us with an office, and get us jobs. In turn they take a small percentage of the gross. Paul Rotha, the great British documentary film maker, is our consulting producer. It is our hope (and the expressed intention of the foundation) that we will get a Rockefeller subsidy starting next year to last for three years to make it possible for us to make many documentary films. That, of course, is most certainly not for publication. But the foundation has said that if there is a producing unit ready to be subsidized, they will give two hundred thousand dollars for production over a three year period. That would more than put us on our feet.

Willard Van Dyke: contact sheet, August 1937, Willard Van Dyke Archive

I would like to know what you think of the Group *f*/64 article in Scribner's. Be sure to let me know your frank opinion. After I had written it and taken it to them, they changed it somewhat, including the deletion of the complete roster of members. They said that their audience would never have heard of most of the people, and so would only skip over that part anyway. As it was, they had trouble getting it all on the one page, and so I couldn't yell very loudly.

I still can't see how you were able to photograph the redwoods, but I am intensely interested. I should love to see more of your new things. Edward, at the risk of seeming presumptuous, I still think I must say to you that I think the printing of the things you sent to Life was below what is possible from the negatives. I don't like the paper nearly as well as Haloid, and I think the prints suffer because of its use. If you like a fast paper, try the new Kodabrom. It has tremendous latitude in exposure and development, and has rich blacks and lots of gradation. Would you think I was being too bold in suggesting that sometime you send me a "tough" negative to print so that you could compare the result with what you are getting? I'd love to do it. It seems to me that the year's work demands the best possible prints to show what you have done.

Love to all of you, and write when you have the time.

Willard

[no return address]

Dear Willard —

Just back after 3 wks in Death Valley. 175 negs — terrific desert wind-sand-storms — rain — rainbows — cold — heat — snow in Panamints — tent cracked down — windshield pitted — in fact everything as jumbled as this description. But I think it the most exciting place in the world, — my world. Took one trip with ranger — his car — into Copper Cañon. C.C.C. [Civilian Conservation Corps] had blasted away a rock obstruction the day before, so our trip was the first ever made in a car, so the first time an 8 x 10 had ever been in. I have never seen such driving, never knew a car could take such a beating, go up, through, such a place.

But my reason for writing now is to acknowledge the express packages. Willard, I wish you were here to receive my — and Charis's — embraces, kisses, etc. etc. etc. And I wish you could have seen the excitement when we opened to the E.W. series. They are simply swell; we roared, and admired. To have these, the only record of this year's Guggenheim, means very much to me, — means more because you were with us. As a photographer I can deeply appreciate all the work involved in making this set, and thank you from my depths.[82]

I don't mean to belittle the package of films; they arrived just in time to see me through a "waiting" period. Again my thanks.

When I looked over my "Life" prints, I realized why you wrote as you did, and wished you had not seen them. I threw all but three away. Enough said!

What bothers me more than the coming printing, is the mounting. I must change the stock which I have been using — which you know — cracks too easily, soils too easily (can't be cleaned), and in time, discolours. I simply cannot afford expensive stock. I realize more and more that, so far as seeing goes, photography will be for me a mass-production medium. I probably will never again use expensive papers and mounts. I have too much to say, see too quickly, produce too many negatives, which to me at least are important, to ever finish them unless in a mass-production way of working. My negatives are easy to print, I can make about 20 "first" prints a day, but even so I have six months printing ahead right now. And I'm still going!

I have searched for a sub.[stitute] for the clay-surface mount I have used for years, but found nothing better. You evidently use something similar, only it is lighter in weight, bends more easily, would take up less space. If you have any suggestion from your experience and contacts in the east, please let me know. I must start printing soon, and I want my mounts for the Guggenheim year uniform.

Guess I am out of luck on the Scribner's, — waited too long, all sold. If you have an extra copy, please send. Would like to read, and have. Or I can write Scribner's.

And once more; be patient and you will get prints for Ralph Steiner and Willard.

Much love dear friend and to Mary —

Edward

4166 Brunswick Ave., Los Angeles, California

Dear Willard:

I know how dangerous it can be to write letters when emotionally "stirred up".[83] In conversation one can modify and qualify, even the inflection of voice or expression in eyes can bring a different meaning; but the written word is pretty stark, can cause misunderstanding. Nevertheless I will have to write, and have to give reasons for my decision to withdraw from the book.[84]

The foreword, which I fortunately read, is not acceptable to me. A man is entitled to express his opinion — I don't believe in censorship nor am I one to dictate — but in the foreword to a book I do object most positively to a gross misrepresentation of my aims, object to being grouped (not to the "group") in the summing up of means and ends.

I do not mind Mr. [David] Wolff's faint praise which damns, (though I would much prefer to have my work condemned or ridiculed), and I can disregard his running commentary on our individual characteristics: "Van Dyke's air-like purity with morbid lyricism . . . Adams' bright frankness . . . Weston's darkness, ingrown sensuality, stone-like seriousness. . ." (which remarks have been greeted with roars of laughter when I have read them to friends). But I do take exception to being quoted and grouped in other statements as though we all had the same ends, all accepted his summing up of the next great step which would automatically make us functional — "truly contemporaneous".

"Quoted"? Yes! Refer to original for these: "they wished", "these men intend", "yet these aims", "preference for flat immobile surfaces", and so on. W h a t unmitigated nerve! What does Wolff know about MY wishes, intentions, aims, preferences? And another quote: their "air of restraint is fear of emotion" — Have you ever noted any air of restraint or fear of emotion in me?

I never answer published criticism, good or bad, about myself. I have found praise often just as wrong and more humiliating than disapproval. One can overlook a stupid newspaper or magazine article, but in the foreword to a book supposed to enlighten the poor benighted masses I will not allow to be published a misrepresentation of my aims, — presented as though by an appointed spokesman.

Even if Wolff did not "quote", wrote merely as a critic, what does he know of my work? Or what does anyone else? Not even my boys have seen more than a quarter of my work. Charis is the only human being who has perhaps seen every photograph I have on hand, and she has seen most of them but once.

No, Willard, I don't mind adverse or even abusive criticism, for I believe in my work, KNOW its importance, and know damn well where I am going without being told.

One difficulty in making any estimate of my work lies in the fact that I have done with a "period" ten years before it becomes popular. Another is that when exhibiting I usually select everything from one period — that which interests me most: the present.

So the arbitrary statement "In this group is defined a period no longer possible", becomes to say the least misleading.

My "faces and postures" period, my heroics of social significance, were done about 1923: the head of the revolutionary Galván, General under Villa, Guadalupe orating (oranting), head of the cement worker, head of Nahui Olín (psychological) etc. My industrial period was over by 1922. My facades, ("Immobile surfaces") were done in Mexico from 1925-27 (when I was accused of being in N.Y. copying another photographer's work). A large collection of pulquerias (only two ever printed for myself) and done before I ever heard of Atget. In this latter period are included interiors of peons' huts and tenement houses.

And what does anyone — except Charis — know of my past year's work? 1300 negatives, — 21,000 miles of searching. No, I have not done "faces and postures", except one dead man (wish I could have found more) and many dead animals; but I have done ruins and wreckage by the square mile and square inch, and some satires.

It seems so utterly naive that landscape — not that of the pictorial school — is not considered of "social significance" when it has far more important bearing on the human race of a given locale than excrescences called cities. By landscape, I mean every physical aspect of a given region — weather, soil, wildflowers, mountain peaks — and its effect on the psyche and physical appearance of the people. My landscapes of the past year are years in advance of any I have done before or any I have seen.

I have profound interest in anyone who is doing a fine job of photographing the "strident headlines", but to point it as the only way in which photography can be "faithful to its potentialities" is utter rot. There are as many ways to see and do as there are individuals — and there are far too few of them.

As I read over the foreword I find more and more to irk me. For example "They wished truest . . . scale in tonal value." I don't give a tinker's damn about being true to nature, — more often than not I am untrue.

But there is much which, though I disagree with it, I cannot object to since it is given as Wolff's personal opinion. Example: his appraisal of Atget. Stieglitz did documents at least as fine in the '90s, and Strand's "Blind Girl" is finer than anything of Atget's to which it could be compared. Atget was a great documentary photographer but is misclassed as anything else. The emotion derived from his work is largely that of connotations from subject matter. So to Mr. Wolff's "nevertheless these five have feeling", I say "Thanks." I have a deep respect for Atget; he did a certain work well. I am doing something quite different.

This letter brings back the one I wrote Seymour Stern 7 years ago, answering his in which he predicted I would be creatively dead buried and forgotten within two years "unless" — Of course I may be to some. But one thing I don't intend doing is to rehash a lot of primer stuff. I don't need to for you, and I am unconcerned otherwise.

You can consider that my withdrawal from the book is because my work has not been defined, merely grouped, and so grouped that I feel very much out of place. Any work or idea a man like Wolff cannot grasp, or does not care to, is labelled "mysticism", "ivory tower art". Anything which

does not fit his narrow pigeon-holing ideology is not "truly contemporaneous".

Leave me out. I only went in to please you and Al. And I will do everything I can to boost the book, — even buy a copy, — for I admire the few photographs I have seen of the "other four" and respect your direction. But I feel like an intruder in the group. Group action is admirable for political purposes, but not for aesthetic reasons. Recall that I tried to resign from *f*/64? Groups in the field of "art" are too much like art colonies.

The kind of group activity which seems really important to me, the kind I have always practiced, is concerned with technique: between photographers there should be an open exchange of advice, discoveries, improvements in method, solutions of technical problems, etc — in other words a freedom from all personal and professional jealousy. I feel that a cooperative attitude on these questions is more than a duty, — a necessity, — for no one person knows all about our medium just as no one person is responsible for the present day automobile.

This letter may sound like a personal attack on Wolff, if so I apologize. I don't know him of course, but if he is your friend I know he must be all right. I have ranted, been superlatively egotistical, but all with reason. I don't want to hurt you or anyone concerned. I hope you will get at least one laugh. [The remainder of the letter is missing]

Letter 50 16 June 1938

Surprise -----› Route 1, Box 162A, Carmel

Dear Willard —

We are building a one-room "Calif-House" in Carmel Highlands, with rent budget & "Westways" contract. Neil doing general contracting. Move in soon.[85] Always a corner for you.

Briefly answering your letter: of course I have no feeling other than that I am in good company with those workers selected for the book. My only quarrel was with the foreword, which so far as I am concerned was misleading.

Al wrote me, asking who I would suggest as possibility to write foreword. I did not want to "butt in" after my stand, but finally suggested that J.T. Morey, whose article on Fourth Int. Salon of

P. P. of A. [Fourth International Salon of the Pictorial Photographers of America] you liked, might be mutually acceptable.[86] I had not thought of Beaumont Newhall as available. I don't want to favor anyone who might favor me, my work. I see no way, no matter who is selected, to avoid favoritism, so I think the foreword must be kept impersonal, despite Al's wishes.

I know in your new work & direction this book must seem in the remote past. It is rather difficult for me to give it the necessary attention. I hardly know what to do about it.

I am truly sorry, Willard, if the "little addenda" disturbed you. I don't even now see how it did. So that clears me, I hope! Of all persons, I want no misunderstanding with you.

Wish I could have heard me by you on radio.[87] I have been on the air a few times — mostly in some scandalous way such as Neil & the statue, trading work for Bach music, but have never listened in.

My new prints, Convira-Amidol, the best I have ever made. Ordered Haloid to try but never got it. The only objection I found with your Haloid prints was in the colour, — too green for me.

Someday you and Steiner will be surprised. I have not forgotten my promise.

Love, & luck in your new adventure,

Edward

Letter 51 21 February 1939

[no return address]

Dear Edward:

Alice thanks you for the violets.[88] And I thank you for two letters. I haven't had much time for writing, either, but things are now quieting down a little bit for me. I hope they don't get too quiet.

I have read with interest the articles in Camera Craft.[89] They are interesting, but they lack a certain Westonish touch. Not that they aren't perhaps more readable, but with no aspersions on either of you, I somehow would have known that you hadn't written them. Never mind, they are good reading, and the prints that the reproductions were made from must be swell indeed. I can visualize them, knowing the clear beauty of your work as I do.

I read with interest of your show in Chicago, and immediately set about trying to promote a business trip that would take me near enough to Chicago so that I could see the show, but I was unsuccessful.[90]

Our picture, tentatively called "The City", is going to be very good indeed, if the music and narration hold up to the production as it is to date. It has been a long haul, with many mistakes made and many lessons learned, but I believe it will make a new step forward — and that is all any of us can do. Maybe a short outline would interest you and Charis.

We start in New England, sometime after 1791 — maybe about the middle of the last century. It is a peaceful place, men go about their work in fresh air and sunshine. They meet together in mutual discussion, they work alone, with their hands they build a life. This is a way of life, planning for the winter, for the spring, but not for the years and the times that their children will live through. The blacksmith works in his shop, the miller grinds his meal, the boy wanders through the graveyard with his dog, reading the tombstones and looking at their quaint and primitive carvings, we come closer to the blacksmith and his work, and as the hammer rings on the hot iron, out of the flying sparks and the smoke, the industrial city is born. Smoke from a thousand chimneys, funnels of smoke pouring dirt and filth into the coves, into the lives of the people. Great ladles pour molten slag onto a seared landscape, children play on railroad tracks, beside scabrous houses — sores and welts on the once-clean earth. Where is the clean grass now? Where is the scythe flashing in the sun? What have we built? Why? Where does this steel go? Now we understand; steel to build a thousand cities, steel over steel rails to push skyscrapers into the blue sky that once knew only the church steeple. Is this what all the smoke is for? This madhouse where people live in deep canyons, rarely seeing the sun, never knowing a tree? Trains roar through the deep gloom, people crush each other physically, and with more delicate tortures. Traffic stands still while taxi meters tick lives and dollars away. Policemen go mad trying to clear the street for the fire engine headed for who knows where. Who cares? The lox-on-pumpernickel at the beanery on the corner is waiting. Who can wait for a fire engine to pass? There is coffee to be snatched in the few minutes before they return to the machines. Thousands of slices of bread. Hun-dreds of pieces of ham, countless gallons of coffee, and always the hungry mouth, filling the sight, forced full of food. Always the toast pops in the toaster, always the griddle machine makes more and more perfectly-done-perfectly-brown-perfectly-awful pancakes. Back to the streets now. Back to the constipation of a great city. Street after crowded street, children play in the gutters, play at their war games on tenement stoops, swim in the open sewer that is called a river. Why? Because a few people didn't plan for their children a decent place in which to live and work. But there is always Sunday. The crowds are gone now. Street after street is empty. No people. No cars. Only the steam from the manhole moves in the quiet air. Where are the people. Come with us to the highway; the people have gone to the country. Mile after mile of cars. Bumper to bumper they move at fifty miles an hour, until a red light changes, and then five miles of cars stop, one after another, brakes squealing. Beside them they see the filling station, the hot dog stand, the beer joint, the vendor selling cheap pottery, or windmills whirling aimlessly on a stick. Again they move, but not so far this time. Someone ahead has a flat tire. Again they stop, and again and again, throughout the whole long "day of rest", until weary and hot, they picnic by the roadside. Is this our heritage? But now there is an airplane propeller turning slowly against the sky fleecy with clouds. A sleek silver plane takes off, and there far below us is a different kind of city. Surrounded by green trees, by a green belt of leaves and grass, lies a little town. Far away, but reached quickly by this plane, or by the fast divided highway, lies the metropolis. Here children play close to nature. Here man may dig again in the earth, and a tree is a thing to be known and loved. This is the thing we wanted, and it is not too late.

This very sketchy outline will give you a rough idea of what we have tried to do. I think we have succeeded. I think it is a good thing we have done. I may be wrong.

Write when you can, it is always good to hear from you, and give my love to Charis and the rest. Mary and Alice and I hope we will be in California this summer.

Love,

Willard

P. S. Your pal Seymour S. [Stern] is here!

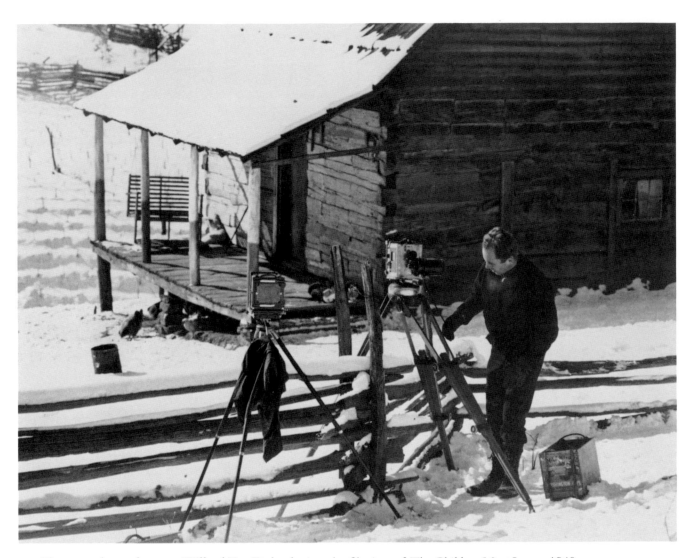

Photographer unknown: Willard Van Dyke during the filming of *The Children Must Learn*, 1940,

Dear Willard —

"The City" again — [91]

Phone calls next day, everyone enthusiastic, even raving! Johan for instance who is going to campaign for another showing here. Gret, Sibyl, O'Sheas, Kochers phoned thanks. From me to you, Steiner, and all concerned, congratulations for a fine job.

Considering it in parts, the first is a beautiful prelude to industrial, mechanical section which is superb. I don't think that I have been so moved, completely held by any film. The cutting, music, void, photography, the satire — raw & subtle — combined to keep me on edge every second. My idea of a well nigh perfect film. I will want to go again and again.

The last part was a let-down — perhaps had to be, and would not be for those to whom the film was especially directed. It was too sweet and well ordered for me, too perfect a solution. But I realize this is a very <u>personal</u> <u>reaction</u>. I would certainly want such an ending for those who came out of the slums. Perhaps the artist can only want Utopia for others. I sat back rather unwillingly after the terrific impact of "The City", waiting for something to happen, — knowing all was over, "they lived happily ever after." Yet I would vote for such a solution.

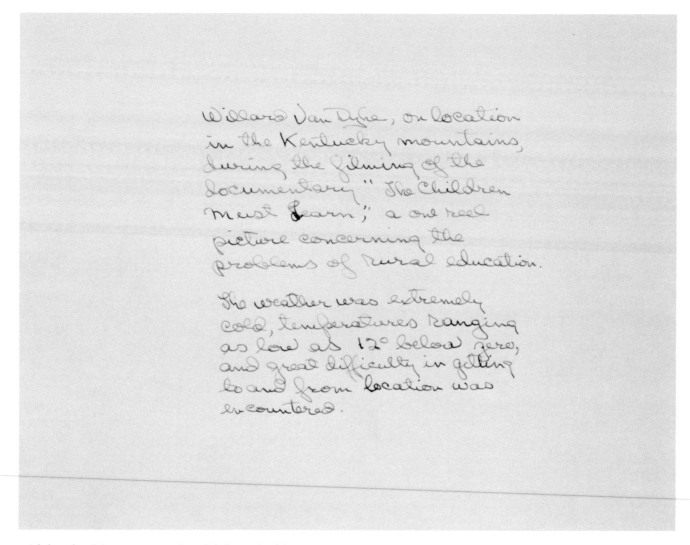

Willard Van Dyke, on location in the Kentucky mountains, during the filming of the documentary "The Children Must Learn", a one reel picture concerning the problems of rural education.

The weather was extremely cold, temperatures ranging as low as 12° below zero, and great difficulty in getting to and from location was encountered.

with handwriting on verso, Ansel Adams Archive

If there is anything to criticize in The City section, I could not see it, or hear it. But I never go to anything — movie, exhibition, prize-fight, in a critical frame of mind. I go to enjoy myself otherwise I would not go at all. I would rather go into the darkroom and print!

One more word: [Lewis] Mumford[92] did a fine piece of work. I objected to the rather pompous oratory in "The River."

Next time you write, tell me how much, or what parts of the photography you did, Steiner did, — or did you work together?

And thanks, many thanks for letting us see "The City."

Always my love and to "la familia" —

Edward

Letter 53 6 November 1939
[no return address]

Dear Edward:

Thanks for the very good letter, and the intelligent appraisal of "The City". It is gratifying to know that you liked it, and that the rest of my friends there did too. I must say that I agree with you completely in your analysis of it. We wanted the ending to be shorter, and to be quite different in structure, but the city planners said that that part was what they had made the picture for, that we had had our fun with the first part, and they were going to do the ending as they wanted it. Significantly enough the ending will be cut ten minutes for

general distribution.

You ask what parts I did, and so on. The New England sequence is almost entirely mine, except for the meeting hall and the weaving. The Industrial sequence I did not work on. The big-city sequence was done almost equally by Steiner, [Edward] Anhalt, and myself. Notably, I did most of the lunchroom stuff, and lots of the people going to work, the skyscraper stuff, the "El" trains, the "accident". Steiner did the taxicab stalled in traffic and the signs. Anhalt did most of the kids, and together we did the fire engine. Some of the traffic on Sunday was mine, most of it was Steiner's. About half of the green city was mine. Some of it was cut from stock shots, and the balance was [Roger] Barlow's. All of the air shots were mine — one shot having been taken in a plane only a hundred and fifty feet off the ground, with the motor cut, and almost in a stall, with me leaning out of the side (from which the door had been removed) with the pilot holding onto my belt. That was quite a thrill.

Mumford, (and also [Henwar] Rodakiewicz, who had no small part in it) did well by the commentary, but for me the music is notably successful. I think [Aaron] Copland did a fine job. He is now doing the music for "Of Mice and Men" on the strength of this.

The next major job I expect to do concerns itself with a different problem, in an entirely different way. It will be on technological unemployment as expressed in a small town, seen through the eyes of a kindly newspaper editor. We never see the man who talks to us, but at intervals the camera moves through the scenes as he would move, and at the climax the people of the town talk to the newspaper man, thus to the camera, and of course to the audience. This is all preliminary thinking, but I think that will be the form, and we start shooting next week.[93] I will direct it, Barlow will shoot it, [Herbert] Kerkow will be business man — or producer — and it will be done with Sloane Foundation money. Naturally the other pictures seem long ago, remotely concerned with today's problem, and "The City" is certainly not looked back upon with much pleasure from a personal point of view. That, of course, because of the personal difficulties that arose.

If Johan succeeds in getting the theatre to run the film again, they can get it through the regular distributors, the World Pictures Corp., at 729 Seventh Ave., N.Y.C. I would appreciate it very much if he would ask for the full version (not the 30 minute one which was cut by someone else, and is bad) and that he specify that he NOT take "Betrayal" with it. The distributors have been trying to make theatres take an inferior film with it, and give the other picture top billing.

Love to all,

Willard

P.S. I hear Strand "came through"!![94]

Letter 54 **8 March 1943**
[no return address]

Dear Willard —

I should put your letter at the bottom of my pile reserved for answers at leisure. But I find that too often letters just stay there awaiting the right day, until suddenly I realize that I "owe" a reply, and rush off a hurried note, forgetting all good intentions.

There is no good reason why I cannot sit me down and write you a good long letter. War duties? Printing? Victory garden? Yes — but even so there are free hours in these days of isolation; one can't garden all day, can't print more than twice a week, can't observe (A.W.S. [Aircraft Warning Service]) more than two or three times a week; or I can't.[95] And today is a perfect day for letter writing, one of those interminable California rains is falling, the kind that end in floods after a week. You see from all that I have not said so far that I am just stalling, not knowing what to say, where to start.

Come to think of it I have been letter writing, as part of my war effort. Maybe I will look back on it as of much more importance than V-garden, A.W.S. or 100 print exhibit for O. of W. I.[96] I write letters of praise or vilification on every worthy occasion such as: telling the Hon. Mrs. Luce that she is sure "the glow-baloney-girl of the year",[97] praising Bill Rogers for his maiden speech against dies,[98] cancelling my subscription to "Life" for their "Open Letter", congrats to [Raymond Gram] Swing & to [Sidney] Roger for their stand on peace and Russia — and — and — and. And believe me letters are noticed; I get quite a few answers, mostly from those I vilify! So perhaps my time is not wasted.

You are evidently pretty unhappy over past and present jobs. I can only hope your talents are not being wasted in this great emergency. No, I wouldn't guess you to be a Republican, not even by sound. I will keep my fingers crossed hoping for your transference to Hollywood.[99] We need you out here; you belong to the West — the future is here. If we get a decent peace our trade (I don't mean just business) with China will be tremendous.

In some miraculous way we manage to earn a good living despite gas-rationing (which stopped tourist travel); a sitting now and then, print sales from unexpected sources, a dribble of royalties — I suppose that by "the book" you mean Leaves of Grass.[100] Yes, it has been published — and stinks to high heaven, a low ebb in book making. My photographs are fairly well reproduced — most of them, but their presentation would wrap you in tears. Look if you must via the Limited Editions Club, Inc., 595 Madison Ave. Oh yes, despite my warnings all the photographs were trimmed — only a ¼ in. to be sure, but often fatal. Our book on the trip will depend first on Charis, then on the war — what war does to books.

(the next day) I got interrupted. And now I am just down from my 6:00 AM watch on Yankee Point (a 300 ft. elevation above Flavin's). A slow two hours with rain, zero visibility and nary a boat, not even a dim-out violation to report. I made a mistake in setting my alarm which got me out of bed at 4:00 instead of 5:00. I'm sleepy.

Chan, so far as I know is still in Conn. He never writes. Brett is photog. for N. American [North American Aviation]. Cole is lead-man at Lockheed, with rumor that he has been asked to teach at Frank Wiggins Trade School, L.A. Neil tried to enlist in Navy; rejected because color blind. So he is back in Lockheed, deferred until April.

A last word on pictures of Alice: No check. Don't forget that I still have your wide angle lens on loan.

Charis is pretty war-busy: Ass. chief at the Post; invented a game, "Army Flash," which is very successful in teaching new recruits how to report planes; and is on call at the Fish Cannery for SOS work.

Finally — I weight down this letter with extra love for Van Dykes big & little —

Edward

[Weston has written a note and drawn an arrow down the left margin of the first page: "This is psychopathic!" Weston is probably referring to his handwriting. The entire page is written at a slant.]

Letter 55 [ca. July 1944]
Wildcat Hill, R.F.D., Carmel

Dear Willard —

I "owe" you a letter.
I "owe" everyone letters.
I "owe" articles.
I "owe" the garden care.
You can plainly see that I have a conscience.

So much has happened since you and crew were here in April. Only 3 months ago, and now Chan is in S.[San] Diego (finished "boat" at Farragut) training to be gunner's mate on torpedo boat. Cole is in USNTS Great Lakes (after passing a stiff preliminary exam).[101] Brett is in photo lab at Camp Crowder, Mo. but will be in school at Astoria, N.Y. very soon. And Neil is in his 32 ft. ketch, commercial fishing (for swordfish), in waters between S.D. [San Diego] and S.B. [Santa Barbara]. All this means there were farewells and farewells, and then visits on leave; I have seen more of boys since inductions than I have in years. But of course that is over now. I see a lot of soldiers & sailors too who find I'm near by and drift out from Ft. Ord, Camp Roberts, Presidio, Del Monte. All this is time consuming but constructive.

Your letter of 4-20 sounded very glum. I hope the weather cleared, that you finally had success. We have had an appalling amount of fog — more than usual. The garden mildews.

The evening with you by the fire, telling your tale of S. American adventure, is vivid in my memory.[102] Some fine day when this mess is over let us plan another longer, brighter, session; we will finish your tale, photograph each other, and for memories sake go out to Pt Lobos, down the coast. Old stuff, but good.

Do you recall Sidney Roger — Domestic & Short Wave commentator? We have had a three day session together recently; like him very much, find he is young, went to Walt Whitman ("Progressive") School with Chan & Brett, & later to Holly.

Willard Van Dyke's Office of War Information identity card, 1943-46, Willard Van Dyke Archive

High in class with Charis. Among other summer visitors, came Nancy Newhall for a strenuous four days.

But I must to the dark-room — to the garden — to an article — to many letters not so pleasant to write. Most of my correspondence goes to my soldier & sailor boys.

Much love, Willard and to Mary and little family — from Edward and Charis joining in — (she may go east on acct. her mother very sick in Wash.)

Letter 56 21 July 1945
[no return address]

Dear Edward and Charis:

What a wonderful, wonderful time I had with you. What a sad bunch of guys I rode away with.[103] We were all deeply touched by the way you re-

ceived us, by all of the things impossible to put into words.

Your letter arrived today, and as I leave for Vermont on Wednesday morning to be gone until the fifteenth of August, I suggest that you send the package on to me care of OWI [Office of War Information] at 35 West 45th Street, or wait until that time and send it here to 70 Bank. In any case, though, it would probably be better to send it to the office, because there is always someone there to receive it. Mary will stay in Vermont until the middle of September. Will you enclose the Aspen print with the other in case you have not already wrapped? I have decided it will look well in the hallway at the farm.

There is one other thing. Each of the boys,[104] quite separately, asked me how they could get a print of one of the pictures of me. I should like to make them such a present for many reasons, not the least of which is that we were all together there. I don't know when we can be together again. I want you to consider this an additional order, and charge me for it as such. Really Edward, because in that way I will be making the present and I want to do it.

I will show them the prints, then they may choose which they like. I judge from the tests that you have printed two of them. They look fine to me, and the difficulty we saw on the negative doesn't seem to have printed through at all.

We had a fine trip home. We went through the Hopi country, stopped at Window Rock, Gallup, Santa Fe, and Taos. The boys bought much very nice jewelry from the Navajo Arts and Crafts Guild in Window Rock, and I got my bow guard in Taos as well as a beautiful bridle. The Grand Canyon may be swell for some people, but after the initial shock it was just a big hole in the ground. It is too much geology and too little anthropology to suit me. We were there on the Fourth of July, and later on that evening we were in Cameron. The cook was in Flagstaff and the restaurant was closed. We bought a frying pan, some canned goods, a lot of eggs, and we cooked our supper out of doors on the bank of the Little Colorado. The next morning just outside Tuba City was the same story — the cook had not returned, so we did the same for breakfast. Of course that is an old story to you and me, but you can't imagine what a sense of excitement it gave those boys. They got out their Leica and shot pictures of the flapjacks, of the campfire, of each other, of everything. It was a fine trip.

Much love to both of you, until we meet again.

<div style="text-align:center">Abrazos, amigos.</div>

<div style="text-align:center">Willard</div>

Willard Van Dyke's Office of War Information press card used during the filming of *San Francisco*, a film about the formation of the United Nations, 1945
Willard Van Dyke Archive

Letter 57 7 July 1948
Affiliated Film Producers, Inc., 164 East 38th Street, New York 16, N. Y.[105]

Dear Edward:

No doubt you are wondering what has happened to the film.[106] I haven't wanted to bother you with all the petty details, but this is a condensed story.

Some months ago, the commentary was written and submitted for approval. State [Department], after some time had passed, took notice of the fact that the part of the apprentice had been changed somewhat. There were explanations and the commentary was approved and recorded with John Carradine doing the speaking. Then State requested a picture change — the elimination of the interior of the abandoned shack in which Franny [Clausen] finds the letter. After some discussion this was done. All this time the question of a musical score was not settled. State did not have the money, they claimed, to do an original score, but they would try to get a special appropriation for it. Time went on, and suddenly we discovered that unless the film was completed and submitted by June 30th, we could not be paid. June 30th is the end of the fiscal year. With this bleak prospect facing us, we recorded a temporary music track and sent the film to State. I haven't seen it in this form and can't bring myself to do so. On Friday I have an appointment with State to see about a score. We are most anxious to finish the film properly. I will keep you informed.

The [Morley and Frances] Baers were here, as you know, and I saw them briefly on two occasions.

I wonder if Cole would mind sending us the negatives he made for Photography. I understand that worthy enterprise has folded. We would like to have prints made which we could use for publicity purposes. Of course, we would return the negatives.

I have had a couple of Eastman color prints made which turned out quite well. Of course, they aren't as good as your transparencies, but they are quite acceptable.[107]

Let me hear from you when you have time.

<div style="text-align:right">~~Sincerely yours,~~ ["Kindest regards," is handwritten above] ·</div>

<div style="text-align:right">Willard</div>

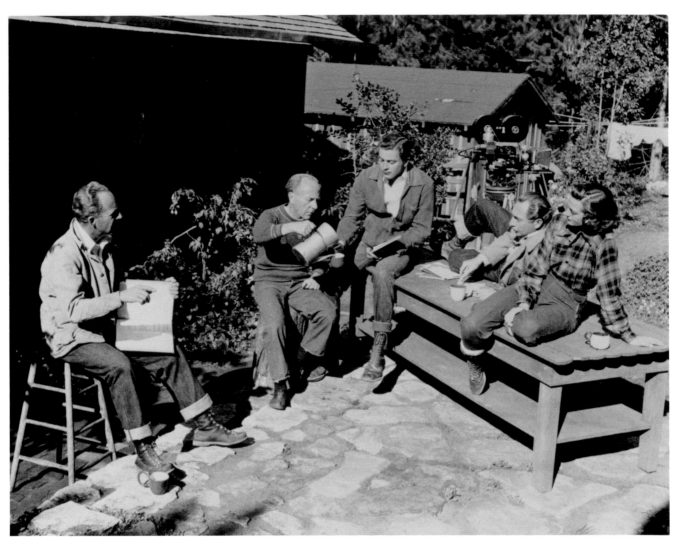

Cole Weston: Willard Van Dyke, Edward Weston, and camera crew, *The Photographer*, 1948, Edward Weston Archive

Letter 58 **21 January [1950]**
164 East 38th Steet, New York City

Dear Edward:

We have no 16mm print, as yet. What about having the theatre run it along with the regular show for a week and give you a part of the "take"? Surely you would increase their business.

You can word the data any way that you like, except that I wouldn't mention the State Department. You can just leave the sponsor out of the press release. The main emphasis should be on you.

It is, of course, the first film made on an American photographer. It might be news worthy to say that I was an apprentice of yours twenty years ago, and that this is my tribute to my "maestro," as well as to the kind of approach to photography and to life that you taught me to respect. If that sounds high flown for newspapers, you can just keep it for yourself. It is true.

I expect to keep on living and growing. This is a painful period, but life is often painful. I don't look upon this as a tragic event, and I have few regrets. The future looks good to me, and I am full of desire to enjoy it. Someday I'll find a girl who loves me as I am and we'll make a good life together. If I don't

44

find her, that will be too bad, but I can still like life and work. I have no feeling of self-pity. What we do is usually of our own making, and it never is all good or all bad.

<div align="right">

Love,

Willard

</div>

Letter 59　　　　　　　　　　　3 March 1950
[no return address]

Dear Edward:

Thanks so much for the report on the showing. I'm so glad it went well.

I think I must have told you that I showed it to [Edward] Steichen and how delighted he was with it. I must confess to a little trepidation before the screening, but it was a complete success.

The good news is that this picture, along with many other State Department films, will be released to the American people within the year. A State Dep't. representative showed it to a large audience in Louisville, Ky. recently with a most enthusiastic response.

I guess we did all right, no? It was wonderful to be able to do it with you, Edward, and I'm happy that I could express my love and appreciation in my own way.

<div align="right">

Willard

</div>

Letter 60　　　　　　　　　　　14 May 1950
[no return address]

Dear Edward:

These days are hectic for me, but I must take time for a note to you. There is news.

First of all, I am to be married again in June. Her name is Barbara Millikin, and she comes from Evanston, Ill. I met her during the filming of the Marriage films last summer.[108] She is twenty-five, very attractive, and quite mature for her years.

The second thing is that I am off for South America early in June to make a film for the State Department.[109] Barbara will meet me in Ecuador, where we will be married. She will work with me down there for three months, after which time we will return here to live. I'm very happy, and it would be complete happiness if we could visit you. You two will like each other.

Franny Clausen was in the other day to see "The Photographer." She brought her new husband, who seems to be a nice guy. She has quieted down a lot — no more cackling laugh.

Sibyl and Simon [Freed] are coming in to town to see the film on the 26th of May. We hope Leon and Callie [Wilson] can join us.

There is no further news on release in the U.S., but it has been promised. The Government moves slowly.

I'm looking forward to your new book,[110] and less so to the story in "Look." The spread in the S.F. Chronicle was very intelligently done, I thought. My mother sent it to me. Drop me a line when you can, it is always fine to hear from you.

<div align="right">

Love,

Willard

</div>

Letter 61　　　　　　　　　　　8 July 1950
Colon Hotel, Quito, Ecuador, America del Sur

Dear Edward:

I never thought I would be back in this place when we passed through over eight years ago, and if the idea crossed my mind my wildest dreams would not have had me here with a wife with whom I would be working and living in complete harmony.

Ecuador has changed a lot, mostly as the result of a few thousand refugees from Europe. When I was here before there were only three hotels, none of which would have been endured any place in the U.S., and no understanding or exploitation of the native arts and crafts. The hotel we are staying in is small, intimate, friendly, and the food is wonderful and completely safe. There is no extra charge for tea and sandwiches any time of day or night. It is run by a German Jew and his wife who worked for five years on a farm to gain their right to remain in Ecuador. Around the corner is Ecuador's first good

dentist, a Jew from Czechoslovakia. And around another corner is a woman from Budapest who designs and makes magnificent rugs, with native motifs, hand-dyed and tied, which are being collected by U.S. museums and sold for much more than modern first class Persian rugs by Shoemaker in New York. There is quite a story in all this.

Barbara and I were married in Mexico City on June 17th. I need not tell you how wonderful it was to have it done there, nor how fine it was to go to Acapulco for our honeymoon. But even you might be surprised at the speed with which we accomplished all this. We had been told in New York that it would take two weeks to get through all the details. Barbara arrived on Friday night. At eight-thirty Sat. a.m., we were having blood taken for Wasserman's. At ten they were reported negative (in any place else in the world the test takes six hours) and at eleven-thirty we were finished with the civil ceremony. At two we were at the altar in the Episcopal church and at three we were drinking champagne with our wedding luncheon. Truly the Mexicans understand the needs of romance (especially if there are a few loose pesos around) and are willing to forward it.

We will be here another two or three weeks, and then are off for either Peru or Bolivia, we don't know which as yet. We're hoping for Peru because high altitude puts unnecessary strains on love. La Paz is above 12,500 ft.

I hesitate to enclose the passport picture [of Barbara], but I know you can make allowances.

Love from both of us,

Abrazos,

Willard

Letter 62 [1951?]

Wildcat Hill, R.F.D., Carmel, California

Dear Willard —

My tardy answer due to visitors — Nancy & Beau Newhall. Nancy will be back on the job soon — that of getting data for a sort of "omnibus", a biography of one E.W. Wish you were closer to check dates and incidents of our mutual lives. I will clear-up the "f/64" source, once and for all! Have you anything to contribute by mail? Anything

printable! Good old prohibition days!

Your letter revealed exciting adventures. I'm so happy for you and Barbara.

Had a surprise visit recently — Wanda!

Looks as though Cole and Dorothy have split up. May be best, but endings can be very sad.

Time to quit — but with love & abrazos for you-all, from — Edward

Letter 63 3 January 1951

164 East 38th Street, New York 16, New York

Dear Edward:

Thanks for the letter. It is always good to see the familiar handwriting on an envelope —

I liked the brochure and I think it was a mighty fine thing for the Baers to do. By this time you will have received NEWS, the magazine published by the ASMP [American Society of Magazine Photographers] and edited by my old friend Martin Harris. I wrote the reviews some weeks ago and the night before they went to press your section was drastically cut, along with a section I had written on the reproductions in the books. I was quite annoyed, because I particularly liked your book, and the way it came out it looks as if the Strand-Newhall volume was my favorite.[111] I had strongly criticized the reproductions in it. I just wanted you to know.

The O'Keeffe film was finally accepted by the State Department and then re-made by them.[112] Because of our trouble with that one, and a few other things, Henwar is no longer with us. We found it was just too tough to try to work cooperatively with a complete individualist. Personally I liked the film as H. did it, even though it didn't have much O'Keeffe in it. He and she haven't spoken since the film was finished.

I believe the film (our film) was shown in Mexico and is still being used there. It has been shown in every camera club in Brazil, with great success. People all over the country keep writing in about it.

The coming year will be a busy one for me. We are deep into the field of mental health films — one way of making analysis pay. But that crack is unfair, it has had a great effect on me in terms of

health and happiness, and I am all through with it for the present. The relief from the financial drain is pleasant.

Love —

Willard

Letter 64 26 July 1951

[no return address]

Dear Willard —

Yes, I am happy to know where to direct people who want to show the film. I have loaned it out several times. Everyone is enthusiastic, even in Brazil.

The "Portfolio" is an enormous task.[113] I have selecting problems. How can one choose 10 prints to represent 50 years of work? Obviously it can't be done. And then question comes shall I make it historical, how much will subject matter enter in? And many more questions. I do not expect my close friends to subscribe. Most of them are in my class, financially speaking! I sent out about 30 letters to a select list, as a feeler (I had to have at least 15 subs.[criptions]). I got them.

Too bad you can't come out this summer. But I'll be waiting —

Love y abrazos — Edward

Letter 65 25 February 1953

Wildcat Hill, R.F.D. 187, Carmel, California
[addressed to Van Dyke at The Plainsman Hotel, Williston, North Dakota]

Dear Willard —

It was a real treat to hear from you. My conscience has been bothering me too. I have to force myself to take up my pen, even when my heart wants me to. Letters to answer remain on my desk in a stack. I think of Ruth Bernhard's story of her father's secret of success: he never opened his mail, he never answered the telephone.

No, I had not heard of your mother's death. My sister [May Seaman] died in Dec. She was my mother, took over the job when she was 14. Neil

has a hospital on his hands: Kraig, who now walks with crutches & braces, and Jana who is getting some use of her bad leg.[114] Helen, Cole's wife is with child again. Brett married Dody![115] As for me, I don't get any better, which means that we were lucky in doing "The Photographer" when we did. I get reports of its success from many sources; from Munich, from Paris, to say nothing of more local showings (pardon me when I peter out).[116] One Santa Barbara teacher called it a "classic."

Good news of Murray Weston, I must meet him and Barbara one day [soon].

An unnamed donor put up $6000.00 for the making of several sets of my work — 1000 to a set.[117] He will retain one complete set; the balance, it is hoped, will go to various museums, libraries, etc. Brett is doing all the printing under my supervision. The first thing we did was to erect a fire proof vault. Neil was the boss of this project. It is made of asbestos, stands alone away from the house, is big enough to stand in.

I am tied in a knot today as you can see, so for fear of taxing your patience and sight I'll wind this up.

Amor y abrazos

Edward —

[Note on envelope in Van Dyke's handwriting: "Pattern for the future. Films, good films, have always led the way toward democracy — toward people working with each other rather than against each other."]

Letter 66 21 December 1953

[no return address]

Dear Edward:

This is just a note to wish you a happy holiday season.

We are all well and looking forward to another baby in May. I have been working quite hard and not as fruitfully as I could wish, but all-in-all things are quite good for me. At the very least I have a wonderful wife.

Our film is one of twenty post-war documentaries to be shown at the Museum of Modern Art during Feb. and March. Tentatively it is scheduled

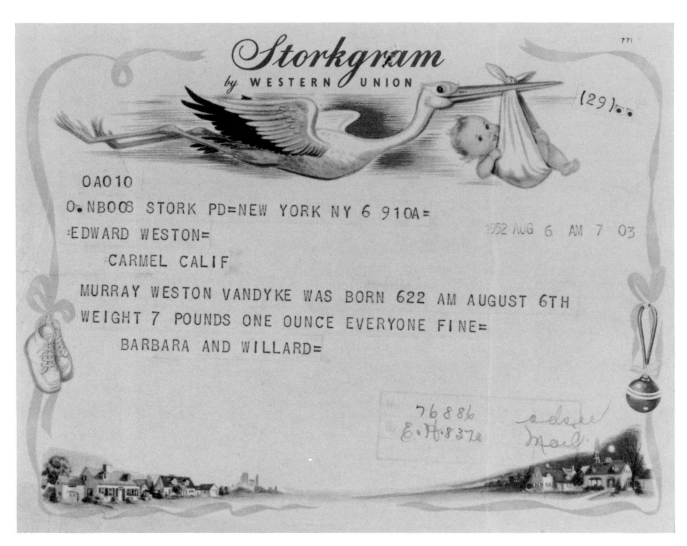

Telegram from Willard and Barbara Van Dyke to Edward Weston, August 6, 1952, Edward Weston Archive

for the week of Feb. 22nd to 28th. Maybe you know people who might want to see it then.

Once in awhile I hear word of your activities, but I rarely see any of the old bunch anymore. It seems to me that the last person who told me about the Weston clan was Irving Lerner.

I have a consulting job in Puerto Rico. I'm supposed to go there three times a year for three weeks. On the last trip I spent much time with Benji [Doniger] who showed Barbara and me a mass of slides he had taken during the filming of THE PHOTOGRAPHER. It was wonderful to see them and to live over again that happy time.

It is just barely possible that I will be driving out to Calif. next summer with Barbara, Murray, and the new baby.[118] We are not sure, but it seems as if

it might be a logical time to do it. If we do, of course we will come to Carmel. I'd love to see you and the boys — and have you meet my family.

Abrazos,
Willard

Letter 67 **11 January 1954**
Wildcat Hill, R.F.D. 187, Carmel, California

Dear Willard —

It was good to hear from you, very good. If you don't get-out to this coast this summer, I'll get you

EDWARD WESTON
WILDCAT HILL,
R.F.D.187, CARMEL
CALIFORNIA

Dear Willard —

It was good to hear from you, very good. If you don't get out to this coast this summer, I'll get you to select a print for my namesake, all autographed to him from me — How is Murray?

Did I tell you that — Kraig broke the spell, had a girl? Then they both had Polio. Recovery is slow.

Thanks for sending info. re m. m. a. showing of "The Photographer": Every now & then I meet some one who has seen it in Siam or Alaska!

Glad you have such a fine wife Willard; She certainly got a swell guy. And another baby on the way!

Those were happy days filming "the Photographer". And the timing was just right. I have not made an exposure nor developed a print since then.

My love to you and your family + a happy Holiday —
Abrazos — Edward — 1-11-54

Letter from Edward Weston to Willard Van Dyke, January 11, 1954, Willard Van Dyke Archive

to select a print for my namesake, all autographed to him from me — How is Murray?

Did I tell you that Kraig broke the spell, had a girl? Then they both had Polio. Recovery is slow.

Thanks for sending info. re M.M.A. [Museum of Modern Art] showing of "The Photographer." Every now & then I meet someone who has seen it in Siam or Alaska!

Glad you have such a fine wife Willard; she certainly got a swell guy. And another baby on the way!

Those were happy days filming "The Photographer." And the timing was just right. I have not made an exposure nor developed a print since then.

My love to you and your family & a happy Holiday —

Abrazos — Edward

Letter 68　　　　　　　　　　**28 May 1954**

[no return address]

Dear Edward:

It was really wonderful to see you again after seven years, and to know that the same old sparks and fire are there.[119]

Barbara and I want so much to visit you in California. We hope it may be next year. I want her to know you and your sons and their wives. One doesn't often find such a good bunch of guys.

Abrazos,

Willard

Letter 69　　　　　　　　　　**16 January 1956**

[no return address]

Dear Edward:

It seems years since I have written to you. Could it have been so long?

The last year was an exciting one for me in some ways and a very bad one in others. I spent three months in Puerto Rico making a film for the government, and that was both frustrating and satisfy-

Willard, Murray, and Cornelius Van Dyke
ca. 1955
Edward Weston Archive

ing.[120] The result is quite good, but I really am not fluent enough in Spanish to do the job of directing as thoroughly as I have done it in English. Barbara and the children went down with me and we saw a lot of Benji and his wife.

Sometime during the course of my stay I picked up amoebic dysentery and spent the summer fighting it. It seems that I have it beaten, but it was a brutal period what with heat of the weather and the pain of the treatment.

Ansel and Nancy spent two evenings with us a few months ago and we had a wonderful time together. He is always so witty, even though I find his philosophical observations thoroughly mystifying (not to say mystical).

A card from Imogen tells me that she will be here in May. It will be good to see the old gal.

Alice [Van Dyke] was with Sadler's Wells Ballet this fall, is on scholarship at the Met and has a small part in their production of "Don Pasquale." She also won a city-wide contest for high school science last fall with her demonstration of blood typing and Rh analysis. She lives just around the corner from us and we see her almost daily. Peter [Van Dyke] is at school in Stockbridge, Mass.

Mary Carolyn has another baby now, another girl. Wanda lives in San Jose now, and my brother has some sort of venture in Carson City.

Irving [Jacoby] and I are plugging along making documentaries. Business has been bad for us because we don't do TV commercials and they pay well, but we have big hopes for this year.

I am sending a recording of some of our film scores. I thought you might be interested. Melvin Powell, who composed them, used to be Benny Goodman's pianist. He has studied with [Paul] Hindemith.

Please give my regards to the boys.

Abrazos,

Willard

Letter 70 [ca. Jan. 1956]
[no return address]

Dear Willard —

I don't know what line of thought to start this letter with, you and I seem to be going through equally bad periods, you with amoebic dysentery and bad business, me with Ol' Doc Parkinson's disease, and bad business too. In re my "b b" I feel humiliated to find that my children had sent out telegrams while I was in the hospital explaining why I was there. To this day I don't know the contents of these letters, or telegrams, I have feared my reactions — collecting "funds" just isn't done by sending telegrams. Then how is it done? I don't know! They meant well.

Willard, I thought the recording you sent me was extra fine. Thank you, mil gracias! Have you done more, or are you going to? The casting was excellent, no?

How is my namesake? And how is Barbara? Have I told you that I am now a great-grandfather? via Ted & Dotty.

I expect I'll find more to say after this is sealed. This being the longest letter I have written in months —

Abrazos y Amor — Edward

Letter 71 31 June 1956
[no return address]

Dear Willard,

Brett & Dody have disappeared in a gulf of visiting & business: they left no N.Y. destination for mail, not with me. Try the "George Eastman House," c/o Beaumont Newhall, Curator of Photography. But I wish you could get a N. York City address. I would like to get a first-hand report on you. I am distressed over your last letter.

Newhalls had a fire in their home,[121] I don't know how much damage was done, can't get a report.

Consider this a note. I'll write more after seeing Brett.

I hope you are better than when you last wrote, & that Barbara & children are well —

With love to you all,

Edward

Letter 72 8 October 1956
[no return address]

Dear Edward:

At last I have seen "The Naked Eye."[122] The film, as I told Lou [Stoumen], is difficult for me to evaluate. It is almost impossible for me to separate my feelings about the events recalled by the images on the screen from the picture as a film. However deeply I was moved, there still are serious reservations.

I must confess that the first-person narration for your section leaves me with a sense of deep dissatisfaction if not downright disgust. Lou tells me that most of the words come from your daybook. Well, perhaps there is a difference between words put down for one's own eyes (or for future generations) and words meant to be read aloud by an actor. Or perhaps the actor needed more understanding direction. Or perhaps the actor just wasn't up to the task. In any case the syrupy delivery was about as far from a truthful representation of you as it could get. I have seriously considered trying to rouse

funds to get another actor to do those sections over again. What do you think?

There were, of course, serious distortions of fact concerning all of the women portrayed in the film. Perhaps this was unavoidable, but I felt Tina could have been handled better. And so could Charis. Again this damned saccarine approach. I don't suggest that complete frankness in this area is necessary or desirable, but one doesn't have to drip honey from the sound track.

I realize the troubles inherent in the situation: how <u>does</u> one make a film about living people and be truthful in essence without stepping on toes? Or inviting a damage suit? But having realized the problem, one goes on to solve it and one solution is to leave out the things you can't be honest about. Another solution is to find a way through the forest of feelings to a clear place where all can meet — subject, filmmaker, audience, and critic. It is not impossible.

I have been expecting to hear from Brett. Isn't he due here for a show? I was sorry to hear about the separation, but it was not unexpected.

Don't bother about writing until you feel like it. I have owed you this letter for a long time.

<div style="text-align: right">Abrazos,</div>

<div style="text-align: right">Willard</div>

Letter 73　　　　　　　　　**28 April 1957**
Wildcat Hill, R.F.D. 187, Carmel, California

Dear Willard

I'll bet you that the parts which offend you, also offend me. I won't go back over the script it might hurt too much. Well, one's reputation can be ruined; no matter that it took 50 yrs. to build.

Thanks for "Press," I did not have them. The parts built from first-person singular. Can you tell me in a few words the most offensive line or thought in the narration? If it passes a line or two, save it.

The effort represented above took me 5 five hours to write down. Believe it or not. (Only ½ to write this. Please destroy this, it's more than a harmless joke.)

I'm now a great-great-grandfather!
Happy days.

<div style="text-align: right">Love,</div>

<div style="text-align: right">Edward</div>

Letter 74　　　　　　　　　**30 April 1957**
[no return address]

Dear Edward:

I was deeply moved by your letter. The effort to write must be formidable.

First of all you must not think that the film has done your reputation any harm. There are thousands of younger people here who had never heard of you, but who now have seen your magnificent work in context with the sensational shit produced by Weegee, the romantic reporting of [Margaret] Bourke-White and the perfectly good news shots done by [Alfred] Eisenstadt. You come off very well, and no one can leave the theatre without a deep feeling of respect for your work and for you.

I object to the sappy way in which [Raymond] Massey reads the parts from your daybook. Or what Stoumen says are "almost exact quotes."

Anyone's daybook contains personal thoughts and observations that seem important when they are written, but your book is also the record of an artist's search. Stoumen passed up the aesthetic inquiry in favor of excerpts, which when read by Massey, take on a sickeningly sentimental quality which is so unlike you that it would be laughable to anyone who knows you.

In addition to this, I dislike the evaluation of Weegee which calls him "compassionate." This is about as far off base as anyone could begin to be. Weegee is a publicity-seeking crudity who never had a kind thought for anyone — except maybe Stoumen who glorifies him by putting him in a movie with Weston. I guess Martin Harris summed it up when he said, "Stoumen is not burdened with good taste, is he?"

There were many distortions which perhaps were inevitable, but which disturbed me. I don't know how else he could have treated Flora, Margrethe, Tina, and Charis, but I know the feelings I

have about them (from knowing you) are quite different from the impressions one gets from the film.

There is something too delicate about the Weston section. It lacks the guts, the passion, the laughter that is so much a part of you and your relations with people. And it also lacks the bitterness I know you must have felt about Charis. Maybe there is no place for these things in such a film, but you can't substitute a vague kind of sentimentality for them.

The dramatic problem of trying to show the essence of an artist's life, his search to find what he must do and the way to do it, his constant probing of the world and himself—this problem has not been solved by the Stoumen movie. On the other hand the picture is only worth discussing because it tries. And because you do emerge to remind us that there is, once in a while, a dedicated spirit who remains true to his medium. Frame after frame, scene after scene, your work shines forth on the screen with such truth and such a feeling of inevitability that the audience is moved in spite of the commentary.

I suppose we who know you are disappointed not to see the Edward we know and love, but thousands who do not know you are being touched and affected.

I am using the camera a bit these days. What a joy it is to get away from the desk and the sponsor and to experience the direct connections between eye, ground glass, lens, and subject.

Regards to all your family.

Abrazos,

Willard

Notes

Materials from several related archives at the Center for Creative Photography are cited under the following abbreviations:

AAA	Ansel Adams Archive
BNNC	Beaumont and Nancy Newhall Collection
DMGA	Dick McGraw Archive
EWA	Edward Weston Archive
SNA	Sonya Noskowiak Archive
WVDA	Willard Van Dyke Archive

UNDATED–1931: LETTERS 1–2

[1] Edward Weston occasionally wrote reviews for area newspapers such as *The Daily Carmelite*.

[2] Mary Jeannette Edwards and Willard Van Dyke met at Piedmont High School, Piedmont, California, in ca. 1924. Van Dyke was introduced to Edward Weston by John Paul Edwards, Mary Jeannette's father, in 1928.

1932: LETTERS 3–12

[3] Kenneth Rexroth wrote an article about Edward Weston titled, "The Objectivism of Edward Weston, An Attempt at a Functional Definition of the Art of the Camera." The article was intended for publication in the *New Review* but was not published. (typed draft, 1932, nine pages, EWA)

[4] Weston was preparing for his second exhibition at Alma Reed's Delphic Studios gallery, 9 East Fifty-Seventh Street, New York City. Alma Reed met Edward Weston in California in July 1930 with José Clemente Orozco and Alfred Honigbaum (*The Daybooks of Edward Weston. Volume I. Mexico, Volume II. California*, New York: The Aperture Foundation, Inc., 1973, p. 175, hereafter, *Daybooks Vol. II*). Reed was Weston's representative on the East Coast, which included arranging prints for inclusion in exhibitions and publications. She presented his first New York exhibition in October 1930. (Maria Morris Hambourg, *The New Vision: Photography Between the World Wars*, New York: Metropolitan Museum of Art, 1989, p. 51, hereafter, Hambourg).

[5] Willard Van Dyke's first solo exhibition was at the M. H. de Young Memorial Museum in San Francisco in May 1932.

[6] Weston's exhibition was from February 29 to March 13, 1932. The exhibition was originally scheduled for early February, but letters from Alma Reed in December 1931 indicate that Weston wished for more time to prepare. (EWA)

[7] Van Dyke worked as a gasoline station attendant for

Shell Oil Company, University and Oxford Streets, Berkeley, California.

[8] In Weston's daybook, he wrote, "I am not so altruistic, so ready to sacrifice, as this gesture seems. In the first place it has to be done, willingly or not, . . . I am about through with the trees and rocks of Point Lobos for the time, nor do the vegetables or still-life indoors excite me: then the camera is old and wobbly . . . I feel like turning to portraits for awhile, . . . I would like a new Graflex, larger, 4 x 5." (*Daybooks Vol. II*, p. 248)

[9] During February and March 1932, An American Place presented a forty-year retrospective of Alfred Stieglitz's work and Julien Levy Gallery exhibited "Modern European Photography." For more information about the galleries and exhibits in New York during the thirties, *see* Hambourg, pp. 50–55.

[10] Ansel Adams wrote a review of Willard Van Dyke's exhibition for *The Fortnightly* in May. "The influence of Weston is very strong, but fortunately more technical than otherwise . . . When he outgrows this pronounced Weston influence I feel that his work will be highly individualistic; his work now impresses me as being (at first glance) pale reflections of Weston." (typed draft, 1932, one page, AAA)

[11] "Chain studios" is a joke by Weston. Chandler Weston had a photography studio in Santa Maria and Brett Weston in Santa Barbara. Brett and Chandler had operated the Santa Maria studio together in 1931, but Brett moved to Santa Barbara in 1932. Weston helped both of them establish the studios. The Santa Maria location was not successful, and Chandler closed the studio in December 1932.

[12] Harald Kreutzberg (1902–1968) was a German concert dancer whose specialty was a demonstration of strong emotion using movement and gesture. He toured the United States and Europe from 1930 to 1939 giving solo performances of dramatic works. For Weston's description of Kreutzberg's performance and the portrait session the next day, *see* the *Daybooks Vol. II*, pp. 253–54.

[13] László Moholy-Nagy had an exhibition at the M. H. de Young Memorial Museum from April 3 to May 2, 1932. (*San Francisco Chronicle*, 3 April 1932, p. D3). His work was first shown in New York by Alma Reed at the Delphic Studios during the fall of 1931 (Hambourg, p. 51). Ansel Adams described the San Francisco exhibition for *The Fortnightly*, May 1932, as "the greatest perversion of serious photography" however, he later included photographs and an essay by Moholy-Nagy in the Pageant of Photography held in the Palace of Fine Arts during the 1940 Golden Gate International Exposition in San Francisco. (AAA)

[14] Weston enclosed the announcement for *Thirty Edward Weston's In A Book* with this letter to Van Dyke. The book was later given the title of *The Art of Edward Weston* by Merle Armitage (New York: E. Weyhe, 1932). The book includes thirty-nine reproductions of Weston photographs. The foreword is by Charles Sheeler, with statements by Weston and Merle Armitage. Lincoln Steffens, Arthur Millier, and Jean Charlot also wrote short statements for the book.

[15] A photographic competition to stimulate interest in the preservation of California trees was sponsored by the California Conservation Committee of the Garden Club of America and the Save-the-Redwoods League. One hundred sixty of the entries were exhibited at the M. H. de Young Memorial Museum, San Francisco, September 21 to October 21, 1932, and twelve awards were given. Edward Weston's *Joshua Tree, Mohave Desert* won a $100 first prize and Van Dyke's *Detail of Madrone* won a $10 seventh place award. (*American Forests*, January 1933). In later years Van Dyke said he did not remember the photograph and did not have the negative.

1933: LETTERS 13–31

[16] The first Group *f*/64 exhibition, November 15 to December 31, 1932, had been sponsored by Lloyd LaPage Rollins of the M. H. de Young Memorial Museum in San Francisco. Their second exhibition was at the Denny Watrous Gallery, Carmel, in January 1933. Denny Watrous generally collected a $10.00 a week handling charge for showing work.

[17] Neil Weston along with seven other boys removed a marble statue from the front lawn of a Mr. Wermuth in Carmel. They put the statue in the middle of the road with a "for sale" sign. The boys were arrested and charged with a civil suit for $500 in damages. The boys appeared in Juvenile Court in Salinas. After hearing the boys's story, the judge decided that the incident had been a prank and dismissed the case. (*Daybooks Vol. II*, pp. 269 and 273)

[18] The letterhead for this stationery is printed in the upper left-hand corner of a vertical sheet and reads, "EDWARD WESTON / Photographer / Carmel — California / — Unretouched Portraits — Prints for Collectors". Weston preferred the letterhead printed on a horizontal sheet.

[19] *An Automatic Flight of Tin Birds* was Van Dyke's first attempt at filmmaking. Preston Holder wrote the script, and Van Dyke determined the equipment needed and was the photographer of the film. Van Dyke describes the film in his unpublished autobiog-

raphy as an, "unfinished 16mm essay in surrealism. . . Preston had thought up the title." The script was written on the back of charge invoice forms from Van Dyke's Shell station. (handwritten film script, ca. 1933, seven pages, WVDA).

[20] The Foundation of Western Art was begun in Los Angeles in early 1933. The institution was started as a noncommercial gallery with the purpose of encouraging new talent in the arts.

[21] Edward Weston took 4 x 5 portraits of Mary Jeannette Edwards and Willard Van Dyke on March 30, 1933. Weston wrote in his daybook entry for February 2, 1933, that he bought a "new 4 x 5 Graflex."

[22] Van Dyke recorded the inscription in *The Art of Edward Weston* in his unpublished autobiography (p. 48, WVDA). The inscription was: "Dear Willard: It would be easy and obvious to inscribe this book with deserved praise for the work you are doing, or I might recall the time you endeared yourself to me by turning down 'the bitch goddess Success' but I would rather say just this, you are one for whom this book was made, more would be less. With love from your friend, Edward."

[23] In a letter to Weston, Merle Armitage says he purchased *Lady Chatterley's Lover* by D. H. Lawrence and that it is "a very powerful book, one of his best." (18 February 1931, EWA). *Lady Chatterley's Lover* was Lawrence's last book, and he continued until his death in 1930 to rewrite and revise the book. *Lady Chatterley's Lover* was privately printed in Florence in 1928 and in Paris in 1929, and an expurgated edition appeared in England in 1932. Weston met D. H. Lawrence in Mexico and photographed him in November 1924. Weston's portrait of Lawrence was included in *The Art of Edward Weston* by Merle Armitage (New York: E. Weyhe, 1932).

[24] The M. H. de Young Memorial Museum was begun by the owner of the *San Francisco Chronicle*, M. H. de Young. Prior to the arrival of Rollins, the de Young Museum was described by the art critic of the *San Francisco Examiner* as "a glorified junk heap, into which all the old families had unloaded all the quasi art which they did not care to destroy and did not wish to keep." (*The Art Digest*, 1 May 1933) Lloyd LaPage Rollins became director of the California Palace of the Legion of Honor, San Francisco, in October 1930 and in February of the following year was also made director of the M. H. de Young Memorial Museum, San Francisco. Rollins placed in storage all exhibits prior to his tenure at the de Young and began to organize new exhibits in the galleries. His actions created enemies, and after two years, Rollins's contract was not renewed.

[25] Ansel and Virginia Adams's first child, Michael Adams, was born in Yosemite, California, August 1, 1933.

[26] Mabel Dodge Luhan (1879-1962) visited Carmel from February through April 1933. Luhan, had moved from New York to Taos, New Mexico, in 1917 and began attracting writers and other artists to visit Taos. D. H. Lawrence, Robinson Jeffers, Dorothy Brett, and Ansel Adams were among those who stayed at Mabel's ranch, Los Gallos. Weston met Mabel and her fourth husband Tony Lujan in Carmel in 1930.

[27] Weston, Sonya Noskowiak, and Van Dyke drove to Taos in late June 1933 and returned to Carmel two weeks later.

[28] Walter Conrad Arensberg (1878-1954) began collecting modern art in 1913 after seeing the Armory Show in New York City and in 1915 became the friend and patron of Marcel Duchamp. Walter and Louise Arensberg donated to the Philadelphia Museum of Art in 1950 their extensive collection of Duchamp's work as well as other modernists. Weston met Arensberg in 1930 in Hollywood, California where the Arensbergs had moved in 1922. Weston describes the experience in his daybook, "Later to his [Arensberg] home, where I saw the most concentrated collection of fine art that has ever been my privilege. . . . I took my work. It was accepted with such thrilling understanding." (*Daybook Vol. II*, p. 140) Arensberg purchased many of Weston's photographs.

[29] Edward Frank Weston (Teddie) was born to Chandler and Maxine on Edward Weston's birthday, March 24, 1930, and was the first grandchild.

[30] The poet, Robinson Jeffers (1887-1962), was a Weston friend and fellow resident of Carmel. He had moved with his wife Una to Carmel in 1914. With money inherited from an uncle, he was able to live on the earnings from his writings. The view from his stone house in Carmel provided the backdrop for much of his poetry. One of the most widely published portraits of Jeffers was made by Weston in 1929.

[31] Weston is referring to Van Dyke's refusal in April 1931 to accept a position with Shell Oil as a district manager in northern California. Van Dyke drove to Carmel to discuss the offer. Weston wrote in his daybook, "he wanted me to back up a decision he had made . . .". (*Daybook Vol. II*, p. 213).

[32] *Thirty Years of Photography: An Exhibition of the Work of Edward Weston from 1903 to 1933* was held at 683 Brockhurst gallery from July 23 to August 12, 1933.

[33] Weston's sister, May Seaman, made arrangements for an exhibition that opened September 16, 1933, at the Increase Robinson Gallery, Chicago.

[34] George Allen Young is listed as editor of *Camera Craft* in September 1933. Young wrote a short article about 683 Brockhurst gallery and the Weston retrospective in the September issue.

[35] Ansel Adams opened his gallery at 166 Geary Street, San Francisco, with "Photographs by Group *f*/64," from September 1 to 16, 1933. Weston, Van Dyke, Henry Swift, Sonya Noskowiak, Consuela Kanaga, John Paul Edwards, Imogen Cunningham, and Ansel Adams all participated in the exhibition.

[36] The Fine Arts Gallery, Balboa Park, San Diego, California, had an exhibition of Group *f*/64 in late July and early August 1933. Katharine Morrison Kahle reviewed the exhibition for the *San Diego Sun* (2 August 1933, p. 5) and wrote, "To be sure, the public will like them [the photographs], but is it not the part of the Gallery to raise, which it does in most cases, instead of meet, the taste of the public?"

[37] Edward Weston wrote the essay for *Henrietta Shore* by Merle Armitage (New York: Weyhe, 1933).

[38] Van Dyke wrote a letter to Sonya Noskowiak, September 4, asking for Joseph Freeman's address. Van Dyke also writes, "Mary Barnett and I appreciated your kind hospitality while we were in Carmel." (SNA)

[39] Jean Charlot wrote the statement for the Increase Robinson exhibition announcement.

[40] Thomas Wolfe's first novel *Look Homeward, Angel* was published in 1929.

[41] Teddie stayed with Weston during most of October while his father, Chandler Weston, worked in San Francisco.

[42] During an exhibition of prints at the Ansel Adams Gallery, San Francisco, in November 1933, Weston was asked how he photographed a cloud. He answered, "I just looked up." (*San Francisco Examiner*, 19 November 1933)

[43] A short review of Noskowiak's exhibit at 683 Brockhurst gallery, November 12 to 26, 1933, appeared in the *Oakland Tribune*. The quote Weston is referring to is, "Real artists are born, not made. I suspect that Sonya Noskowiak, who, they tell me, is young and lives in Carmel, was born that way. That seems sad, but it's too late to do anything about it now. Her exhibition of photographs at 683 Brockhurst, Oakland, shows that she has all the fine dramatic instincts of a true artist."

[44] *The Spectator: A Journal of Progress for Oregon and Pacific Northwest*, Portland, Oregon, (4 November 1933) had a review of an exhibition including Oregon and California photographers at the Museum of Art in Portland. The full quote reads, "The California group of Edward Weston and his followers, (for Brett Weston, Willard Van Dyke, Ansel Adams and Sonya Noskowiak seem influenced by his work) often termed the 'F-64' group, represent a distinct application of photography. The work of Edward Weston, particularly, shows fine technical composition and artistic viewpoint, unusual subject matter and portrayal of form. The entire group seems to feature objective representation of carefully selected forms."

[45] Weston is referring to his exhibition that opened January 2, 1934, Haggin Memorial Galleries, San Joaquin Pioneer Museum, Stockton, California.

[46] Albert Jourdan curated the photographic exhibition at the Museum of Art, Portland, Oregon, in November 1933. He was also one of four Portland photographers included in the exhibition with the *f*/64 photographers.

[47] Sergei Eisenstein (1898-1948), Russian film director, went to Mexico in ca. 1931 to make a documentary film about the Mexican culture and the revolution. Eisenstein and his cameraman, Eduard Tisse, had finished filming the documentary to be called "Que Viva Mexico" when the project was canceled in 1932. The unedited film was taken from Eisenstein, and he returned to Russia. Sol Lesser, a Hollywood producer, assembled the footage, and the film was released as *Thunder Over Mexico* in 1933. Film journals and critics of the period wrote that Eisenstein should have been allowed to assemble the footage using his own ideas for the montage.

[48] *Cavalcade* was a film made by the Fox Film Company of America and released in 1933. The film was based on a Noel Coward play and made almost entirely with British actors. *Cavalcade* won an Oscar for Best Picture of 1932-33. The film followed a British family from the turn of the century until the end of 1932. Montage scenes were used to illustrate historical events of the twenties.

1934: LETTERS 32–41

[49] Mills College Art Gallery, Oakland, California, had a photography exhibition in February 1934. Some of the California photographers included in the exhibition were: Edward Weston, Ansel Adams, Imogen Cunningham, Dorothea Lange, Willard Van Dyke, Alma Lavenson, John Paul Edwards, Sonya Nos-

kowiak, and Henry Swift. Eastern photographers included Louise Dahl-Wolfe, Thurman Rotan, Margaret Bourke-White, Ira Martin, and Charles Sheeler. Roi Partridge was an instructor at Mills College from 1920 to 1946. He became chairman of the art department and was the director of the art gallery. He may have curated this photography exhibition at Mills College.

[50] Weston wrote in his daybook, "Alma [Reed] wired me for an exhibition to open Jan. 29th . . .She has owed me money for prints sold months ago, has promised it 'return mail,' time and again. I need the money, and I'm tired of her unbusinesslike approach." (*Daybooks Vol. II*, p. 280)

[51] Weston is referring to Ansel Adams's first New York exhibition at Alma Reed's Delphic Studios gallery in November 1933. Adams wrote Alfred Stieglitz in May 1934 that Delphic Studios had not 'handled' his exhibition well. He believed that little effort had been made to bring the exhibition to public attention. Reprinted in *Ansel Adams: Letters and Images, 1916-1984* (Boston: New York Graphic Society, 1988), p. 69, hereafter, *AA: Letters*.

[52] Nacho Bravo, a photographer, is described in Weston's daybook as part of the "newly established Mexican Consulate." (*Daybooks Vol. II*, p. 273). Bravo's photographs were included in The First Salon of Pure Photography at 683 Brockhurst gallery in July 1934. (*Camera Craft*, September 1934, p. 420)

[53] The American Forestry Association held a contest for "The Most Beautiful Photographs of Trees in America." The Association held the competition from May 1 to October 31, 1933, and then distributed $450 in prize money. The $200 first place winner was T. O. Sheckell, East Orange, New Jersey, with a photograph of wind blown trees in Utah titled *In the Path of the Storm*. Six hundred of the entries as well as the five winners were exhibited at the National Museum, Washington, D. C., in November and December 1933. (*American Forests*, January 1934)

[54] *The Autobiography of Alice B. Toklas* was published in 1933 by Gertrude Stein (1874-1946) and was a bestselling autobiographical novel about Stein's life in Paris during the twenties.

[55] See Weston's daybook entry for 6 January 1934 for a description of portraits, nudes, and landscapes he was currently working on.

[56] William Alexander in *Film on the Left: American Documentary Film From 1931 to 1942* (Princeton, New Jersey, 1981, p. 130) gives a description of Van Dyke's "protest." Alexander's book is based in part on interviews with Van Dyke. He says that Van Dyke tried to organize disgruntled Shell employees into a union because they had been asked to work sixty hours per week. Shell management said that they "controlled the local Teamsters" and Van Dyke was faced with continuing to work sixty hours a week or no job. He chose to quit working for Shell.

[57] Edward Bruce headed the Public Works of Art Project, a division of the United States Treasury Department, in December 1933. Artists were placed on weekly salaries to create works of art to be distributed to public institutions such as libraries and schools. The art became the property of the United States government. Merle Armitage was the Regional Director for the Public Works of Art Project in Los Angeles. He hired Weston on January 11, 1934, as a photographer for the southern region of California at a weekly salary of $42.50. (Merle Armitage to EW 12 January 1934, EWA). Weston's salary was later reduced due to budget problems.

[58] Van Dyke was chosen in ca. February 1934 from fifty applicants to be the photographer for the Public Works of Art Project for the northern region of California. (*Daybooks Vol. II*, p. 281) Van Dyke was notified by Edward Bruce that the Civil Works Administration would no longer employ artists after 28 April. (Edward Bruce to WVD, 17 April 1934, WVDA) His employment ended because the Civil Works Administration was terminated in the Spring of 1934. The Public Works of Art Project was the forerunner to the Works Progress Administration, Federal Art Project.

[59] Walter Gieseking (1895-1956) was a German concert pianist known for his performances of works by Debussy and Ravel.

[60] Weston was photographing the paintings for the Public Works of Art exhibition at the Los Angeles Museum, Exposition Park.

[61] Chandler Weston helped Edward develop negatives from the Public Works of Art Project.

[62] *Camera Craft* announced in March 1934 that Van Dyke and Mary Jeannette Edwards would have a First Salon of Pure Photography at their gallery at 683 Brockhurst, Oakland, in July 1934. The printed announcement from 683 Brockhurst gallery lists Edward Weston, Ansel Adams, and Willard Van Dyke as the jury for the salon. John Paul Edwards wrote an article for *Camera Craft* in September 1934 in which he described the Pure Salon. He says that 600 photographs were submitted from which 57 were selected. The *Camera Craft* issue also published some photographs of the

selections. In September the exhibition was shown at the Adams Danysh Galleries in San Francisco.

[63] Thomas Craven (1899-1969) was an art critic and lecturer during the thirties who championed American regional painters. Craven particularly disliked the French influence on American painters. He was described by Arthur Millier in 1932 as "an art evangelist, whose self-stated aims are to awaken the American artist to his task of living and interpreting American life." (*The Art Digest*, 1 May 1932) Harriet Dean mentions in a letter to Weston that she is enclosing an article about Diego Rivera by Craven. (15 May 1934, EWA). An article published in *Scribner's Magazine* (March 1934, pp. 189-94) by Craven argues that Rivera was an artist in Mexico because his murals represented his Mexican experiences. Craven says that Rivera's American murals "seldom rise above prodigious competence" because they are not based on "real American experiences" but rather Rivera's view of capitalist America. Craven was a controversial critic whose ideas would undoubtedly have been discussed by Weston's circle of friends.

[64] Van Dyke and Ansel Adams discussed starting a publication relating to straight photography. The WVDA contains four letters, from 1932 to 1934, between Adams and Van Dyke in which Adams writes about which photographers should be included in *f/64* exhibitions and an outline for publishing an annual photography publication. (The four letters are photocopies of five typescript pages; the origin of the typescript is unknown; whereabouts of the original letters is unknown.)

[65] "The Photographs of Dorothea Lange — A Critical Analysis" was published in *Camera Craft*, October 1934, pp. 461-67. The article included five photographs by Lange. In his unpublished autobiography, Van Dyke credits his friendship with Lange as leading to a subtle change in the subject material of his photographs and his desire to document the depression. Van Dyke's method of recording the depression would be documentary filmmaking rather than still photography.

[66] Van Dyke may be referring to Donald Brown, husband of Virginia Moss Brown, a student of Weston's. (*See* letter from Virginia M. Brown, Box 437, Los Altos, California, 31 August 1934, EWA)

[67] Oscar Maurer (1871-1965) was a California landscape photographer.

1935: LETTER 42

[68] Edward Weston moved from Carmel to Santa Monica, California, in June 1935. He and Brett Weston operated a portrait studio with Edward as photographer and Brett doing the developing and printing. Edward, Brett, Neil, Cole, and eventually Charis Wilson set-up housekeeping together in a small house.

[69] Nina Collier worked for the Soil Conservation Service in Washington, D. C. She asked Van Dyke to Washington to screen his documentary film about the UXA cooperatives near Oroville, California. (A film made with Preston Holder in late 1934).

[70] Van Dyke's statement that Strand had recently returned to New York helps in dating this letter. Paul Strand returned to New York from Mexico in December 1934 after completing his film *The Wave* (*Redes*). He traveled to Russia for two months in May 1935.

[71] Van Dyke traveled to Europe with family friend Charles Cadman, a composer. They went to Russia where Van Dyke was interested in learning more about filmmaking and theater. The WVD Archive contains a manuscript by Van Dyke in which he describes his impressions of Russia and Leningrad during June 1935.

[72] When the Resettlement Administration was formed in April 1935, Pare Lorentz became the motion picture consultant. He was given authority to produce and direct a dust bowl film. Paul Strand, Ralph Steiner, and Leo Hurwitz were chosen for the camera work and began filming *The Plow That Broke The Plains* in September 1935. (Robert L. Snyder, *Pare Lorentz and the Documentary Film*, Norman, Oklahoma: University of Oklahoma Press, 1968, pp. 27-29)

1937: LETTERS 43–46

[73] T. J. Maloney, editor of *U.S. Camera* had asked Weston to help make the selections for the 1937 edition. In the foreword of *U.S. Camera 1937* Maloney wrote: "Edward Weston and Major A. W. Stevens were also judges, but due to the press of other commitments, sent their regrets at the last moment. They will serve on next year's committee."

[74] Van Dyke describes the "undecided job" in his unpublished autobiography. "Peter [Stackpole] persuaded *Life* to assign us both — he with his 35mm Leica, I with my 8 by 10 view camera — to make a trip across the country, photographing as we went." Peter Stackpole was a staff photographer for *Life* magazine. He and Van Dyke traveled across the southern part of the U.S. during June and July 1935 and photographs from this trip were published in *Life*. For Van Dyke's experiences on this trip see the letters written to Mary Gray Barnett, WVDA.

[75] The exhibition, *Photography: 1839-1937*, was curated by Beaumont Newhall and opened at the Museum of Modern Art in March 1935. Edward Weston had five photographs of *Dunes, Oceano*, 1936. Of the four Brett Weston photographs included, Van Dyke refers to the *Wet Emery Powder on Glass*, 1936.

[76] Weston had a one person exhibition at Nierendorf Gallery, 20 West 53rd Street, New York from 30 March through 18 April 1937. Karl Nierendorf had previously exhibited Weston's work in Germany.

[77] *Life* published a short article, 12 April 1937, announcing Weston's Guggenheim and stating that he founded Group *f*/64. Martin Harris, a photographer and friend of Van Dyke's, then sent a letter (*Life*, 3 May 1937) which stated that Van Dyke was responsible for the "organization of the group."

[78] Van Dyke visited with his mother in Piedmont, California after the trip with Peter Stackpole ended in July 1937. Weston and Charis Wilson had begun their Guggenheim travels by then.

[79] While Edward and Charis were visiting Ansel and Virginia Adams in Yosemite in late July 1937, Adams's darkroom burned. After putting out the fire, they spent the rest of the night washing negatives in an attempt to save as many as possible. (*AA: Letters*, Adams to Stieglitz, 29 July 1937)

1938: LETTERS 47–50

[80] *Scribner's Magazine*, 103:3 (March 1938), published an article by Van Dyke, "Group *f*/64." The article included Weston and Van Dyke photographs.

[81] Ralph Steiner and Van Dyke left Frontier Films in December 1937 and formed American Documentary Films, Inc. William Alexander in *Film on the Left* gives a detailed account of the break with Frontier Films. He says that after Van Dyke returned from his trip with Weston and based on the autonomy Pare Lorentz had given him in filming *The River* in 1936 and 1937, he was unhappy with his "junior group" status at Frontier. Steiner was also unhappy with his secondary role. When Steiner was approached by the American Institute of Planners to make a film for the New York World's Fair, he and Van Dyke resigned and began work on what would become *The City*. The break caused hard feelings with others in Frontier Films because several members felt *The City* should have been their film. (Alexander, pp. 178-84)

[82] Van Dyke sent photographs from the August 1937 trip he made with Weston and Charis along the northern California Coast.

[83] The last pages of this letter are missing. This fragment is a photocopy and was found in the Van Dyke archive. The locations of the handwritten and typescript originals are unknown. Although Weston rarely typed letters, he may have asked Charis to type this one. He wrote to Adams, "Read the forward by Wolff and could not stomach it. Have written 12 pages (longhand) to Willard giving reasons for my withdrawal. Am holding until C returns to type with duplicates for Al Young & for me." (14 April 1938, EWA).

[84] Discussion for a book began in 1935 between Willard Van Dyke and George Allen Young (Al) of *Camera Craft*. [See Letter 43, ca. April 1937]. Young wrote Weston in May 1937 requesting an essay for the book. Letters between Weston and Adams in April 1938 suggest that all the photographers (Weston, Adams, Ralph Steiner, Van Dyke, and Walker Evans) were asked for an essay. The book was to be titled "Five American Photographers." Weston and Adams resigned from the book project because of their objections to the foreword by Wolff, and the book was never published. (EWA) David Wolff and David Forrest were pseudonyms used by Ben Maddow during this period. He and Van Dyke worked on several documentary film projects together and Maddow often used his pseudonyms when he was not working for Frontier Films. (Alexander)

[85] Edward and Charis Weston moved into the Wildcat Hill house in late July 1938.

[86] An article about the Fourth International Salon of Pictorial Photographers by J. T. Morey was published in *Camera Craft* in August 1937. Morey wrote that "pictorialists and purists" were exhibited together but on opposite sides of the room. Morey mentions that one can see earlier work by noted "purist" photographers. In describing Weston's photograph *Armco Steel, Ohio*, 1922 he says, "Weston, who is as honest as his lens and apparently always has been, was an F64ist in 1922."

[87] A rough draft of the script dated 16 September 1937 is in the Willard Van Dyke Archive. Van Dyke discusses Weston's Guggenheim work and his short trip with him in August 1937.

1939: LETTERS 51–53

[88] Their first child, Alice Gray Van Dyke, was born to Willard and Mary Van Dyke on January 20, 1939.

[89] Van Dyke is referring to articles written by Charis Weston, but carrying Edward's name as author. The articles published in *Camera Craft* were "What is a Purist" in January and "Photographing California" in February. Part II of "Photographing California" was published in March, "Light vs. Lighting" in May and

"What is Photographic Beauty" in June 1939.

[90] Weston had an exhibition at the Katharine Kuh Gallery, Chicago in January 1939.

[91] *The City* was a humorous depiction of urban life. The film was shown two times a day, four days a week for one and half years at the New York World's Fair beginning in 1939. The film was very popular at the Fair although critics, both then and now, find fault with the too perfect ending. The film was made for the American Institute of Planners which wanted the ending to show a "model" city and objected to the humor. The humor and the ending with the model city were in the final version of the film.

[92] Henwar Rodakiewicz tried to the write the narrative for *The City* but was unhappy with the results. He gave the job to Lewis Mumford who wrote the final narration.

[93] The documentary film *Valley Town*, Van Dyke's personal favorite, was released in 1940 and examines the life of an unemployed Pennsylvania steelworker. The film was produced by the Educational Film Institute of New York and Documentary Film Productions, Inc. Van Dyke and Herbert Kerkow formed Documentary Film Productions in 1939. Van Dyke and Steiner's collaboration lasted one year due to personal difficulties having mainly to do with Steiner's distaste for corporate sponsors. Steiner and Van Dyke did, however, remain life long friends.

[94] Weston asked for photographs from Paul Strand to illustrate an article he was writing for *Encyclopaedia Britannica*. In a letter from Strand to Weston, 8 October 1939, Strand mentions that Van Dyke forwarded Weston's letter to him from New York to Maine where he was "getting material for a film." Strand agreed to send two prints for inclusion in the encyclopedia. (EWA). Ansel Adams received from Weston a carbon of a letter, 6 April 1940, to Walter Yust, the editor of *Encyclopaedia Britannica* in which Weston complained that the photographs had been cropped in the proofs. Weston told Yust to write Alfred Stieglitz, Paul Strand, Charles Sheeler, Edward Steichen, Ansel Adams, and Brett Weston for approval of the proofs. Later correspondence reveals that Yust corrected the problem. (AAA). The article was published as "Photographic Art," *Encyclopaedia Britannica*, vol. 17 (1941).

1943: LETTER 54

[95] Weston was a member of the Ground Observer Corps, U.S. Army Air Forces, IV Fighter Command, Aircraft Warning Service.

[96] Weston had a 102-print exhibition with the Office of War Information, New York City, November 1942.

[97] *Life* magazine, 22 February 1943, reported that Clare Booth Luce, a Connecticut Representative, had coined the word "Globaloney" in a speech to the United States House of Representatives. She criticized Vice-President Wallace for his unrealistic "global thinking." He had suggested that the United Nations operate global airlines after the war.

[98] In a note in the margin on the second page Weston writes, "May be more than accident that I wrote with small d---" Weston is commenting on how the Dies Committee did not die in the House of Representatives. In 1938 the United States House of Representatives established a committee to investigate un-American activities. Martin Dies, Representative from Texas, was made chairman. Weston praises Bill Rogers, a representative from California, who voted to disband the Dies Committee. The vote was 302 to 94 for Dies. Although Dies's activities were criticized as undemocratic, the committee was made permanent in 1945 and was a precursor to the McCarthy era. In 1947 investigations began into alleged communist affiliations in the film industry.

[99] Van Dyke was Chief of Production and Liaison with Hollywood writers for the Office of War Information, Overseas Motion Picture Bureau (OWI) from 1943 to 1945. The Overseas Motion Picture Bureau was producing films to be shown in other countries to convey positive ideas about life in the United States. Film scripts from this era are in the WVDA.

[100] *Leaves of Grass* illustrated with Weston's photographs was published by the Limited Editions Club, New York in 1942. Although Weston believed the reproductions in the book to be excellent, he strongly objected to the green-tinted pages. Weston also disliked the shape of the book which is vertical while most of his images are horizontal. (EW to Armitage, 29 December 1942, Harry Ransom Collection, University of Texas, Austin). Zohmah Charlot described the green pages as, "Spanish bathroom nile green." (Zohmah Charlot to EW, 15 April 1943, EWA)

1944: LETTER 55

[101] Cole Weston attended United States Naval Training, Great Lakes, Illinois, during Spring 1944.

[102] Van Dyke and Ben Maddow traveled to South America in the winter of 1941 to 1942 to make the film *The Bridge* for the Foreign Policy Association. A diary by Ben Maddow of this trip can be found in the Van Dyke archive.

1945: LETTER 56

[103] Van Dyke spent three months in California making *San Francisco*, a documentary about the formation of the United Nations. This was the last film Van Dyke directed for the Overseas Motion Picture Bureau. This letter suggests that he and the film crew visited Weston at the end of filming.

[104] Van Dyke is referring to the film crew of *San Francisco*.

1948: LETTER 57

[105] Van Dyke, John Ferno, Irving Jacoby, and Henwar Rodakiewicz founded Affiliated Film Producers, Inc., in 1946. They proposed a series of films for the United States Information Agency, United States State Department about American artists.

[106] In 1947, Van Dyke began work on a film for the United States Information Agency about Edward Weston called *The Photographer*. Generally, Van Dyke was either producer or director for the documentaries made by Affiliated Film Producers. He chose to be the photographer as well as the director for this film. Ben Maddow and Irving Jacoby wrote the script, Benjamin (Benji) Doniger and Larry Madison were Van Dyke's assistants, and Franny Clausen was the actress hired to play Weston's apprentice in the film.

[107] Dr. George L. Waters, Jr. of the Eastman Kodak Company asked Weston to try color film, and Weston began to experiment with color between 1946 and 1948. Kodak used some Weston transparencies in their advertising campaign. For Weston color work was a new challenge. (Information from an essay by Terence Pitts, *Edward Weston: Color Photography*, Tucson, Arizona: the University of Arizona, Center for Creative Photography, 1986, p. 11-12) Weston made color transparencies during the filming of *The Photographer*. He wrote to Beaumont Newhall that they would be traveling to Oceano, Point Lobos, and Death Valley and that he was beginning the trip with "6 doz 8x10 Ektachrome, and couple of cases of Super Pan. Pres. I've gone Eastman!" (EW to Beaumont Newhall, 6 September 1947, Museum of Modern Art, photocopies BNNC)

1950: LETTERS 58–61

[108] Van Dyke directed five films for McGraw-Hill on courtship and marriage at Stephens College, Columbia, Missouri.

[109] Van Dyke directed *Years of Change*, 1950, for the United States Information Agency. The script was written by Irving Jacoby and photography was by Richard Leacock.

[110] *Edward Weston: My Camera on Point Lobos*, (Yosemite: Virginia Adams and Boston: Houghton Mifflin, 1950) was edited by Ansel Adams. It contains an essay by Dody Warren and excerpts from Weston's daybooks. The book has thirty, 8 x 10 reproductions and sold for $10.00.

1951: LETTERS 62–64

[111] Van Dyke reviewed four photography books in an article titled "The Masters Look at America" for *ASMP News* (December 1950, pp. 8-9). The books reviewed were *Time In New England* (New York: Oxford University Press, 1950) with photographs by Paul Strand and text by Nancy Newhall, *The Land of Little Rain* (Boston: Houghton Mifflin, 1950) with photographs by Ansel Adams and text by Mary Austin, *My Camera in the National Parks* (Yosemite: Virginia Adams and Boston: Houghton Mifflin, 1950) with photographs by Ansel Adams, and *Edward Weston: My Camera on Point Lobos*. In the article the Weston and Adams photographs are described as "beautifully reproduced" but the reproductions in *Time in New England* are not mentioned.

[112] The film was released with the title *Land of Enchantment* and is described as "an impression of the Southwest reflected through the eyes of artist Georgia O'Keeffe." (WVDA)

[113] The *Fiftieth Anniversary Portfolio* contains a personal statement and twelve photographs printed by Brett Weston from Edward's negatives. The portfolios were made by Grabhorn Press, San Francisco and sold for $100.00 each.

1953: LETTERS 65–66

[114] Kraig, Neil Weston's wife and his daughter, Jana, contracted polio in 1952.

[115] Dody Warren Thompson, photographer and author, was Edward's assistant and was married to Brett Weston from 1950 to 1958. Her writing includes the text for Edward's *My Camera on Point Lobos* and the introduction for *Brett Weston: A Personal Selection* (Carmel, California: Photography West Graphics, 1986).

[116] Weston's advanced Parkinson's disease resulted in cramped, slanting, almost eligible handwriting. Weston makes other references to his handwriting in subsequent letters.

[117] Correspondence during 1952 to 1953 between Dick McGraw and Edward and Brett Weston suggests that Dick McGraw was the "unnamed donor" of $6000. The prints from this project are now known as the Edward Weston Project Prints, but the project is referred to in the correspondence as the "EW Print Project" by the Westons and the "Comprehensive Series" by Dick McGraw. (Brett Weston to Dick McGraw, 6 August and 2 September 1952, and Dick McGraw to EW, 27 August 1952, DMGA; Dick McGraw to EW, 14 November 1953, EWA)

[118] Cornelius John Van Dyke was born April 13, 1954.

1954: LETTERS 67–68

[119] Van Dyke lectured at the San Francisco Museum of Art, Civic Center on May 14, 1954. He was part of a weekly film and lecture series sponsored by the museum and spoke on "The Tradition of the Documentary Film." (WVDA) This letter suggests that he and Weston saw each other while Van Dyke was in California.

1956: LETTERS 69–72

[120] Van Dyke co-directed *El de los Cabos Blancos* for the Puerto Rican Department of Education. Van Dyke also made *Mayo Florido*, an experimental color film. A copy of this experimental film can be found in the Anthology Film Archives, New York.

[121] Beaumont and Nancy Newhall had a fire in their Rochester, New York, home in April 1956 that caused considerable damage to the house and furnishings. The study sustained less damage, and the manuscripts each was working on at the time were saved.

[122] *The Naked Eye*, a documentary film about the art of photography, was written, directed, and produced by Louis Clyde Stoumen in 1956. Dody Warren [Thompson] assisted Stoumen and the narration was by Raymond Massey. In the United States the film was given the Robert J. Flaherty Award for "Creative Achievement in Documentary Films" in 1956 and received awards in Europe as well. The film traced the history of photography and included work by Weegee, Margaret Bourke-White, and many others. The majority of the film was an appreciation of Edward Weston's photography.

Inventory of the Letters

★ Enclosure is included with the letter. Number of pages listed does not include enclosure.

+ Pages are missing.

Letter	Date	Author	Pages	Collection
1	[early 1930s]	Van Dyke	1	Weston
2	21 June 1931	Weston	1	Van Dyke
3	5 January [1932]	Van Dyke	2	Weston
4	[ca. January 1932]	Weston	2	Van Dyke
5	20 January 1932	Weston	2	Van Dyke
6	17 February 1932	Weston	2★	Van Dyke
7	3 March 1932	Van Dyke	2	Weston
8	5 March 1932	Weston	4★	Van Dyke
9	14 March 1932	Weston	2	Van Dyke
10	21 April 1932	Weston	2	Van Dyke
11	26 July 1932	Weston	2★	Van Dyke
12	10 October 1932	Weston	2★	Van Dyke
13	27 January 1933	Weston	2	Van Dyke
14	7 February 1933	Weston	2	Van Dyke
15	20 February 1933	Weston	2	Van Dyke
16	2 March 1933	Weston	2	Van Dyke
17	8 April 1933	Weston	2	Van Dyke
18	21 April 1933	Weston	1	Van Dyke
19	24 April 1933	Weston	1	Van Dyke
20	7 June 1933	Weston	2	Van Dyke
21	8 July 1933	Weston	4	Van Dyke
22	14 July 1933	Weston	2	Van Dyke
23	18 July 1933	Weston	2	Van Dyke
24	31 July 1933	Weston	2	Van Dyke
25	8 August 1933	Van Dyke	2	Weston
26	15 August 1933	Weston	2	Van Dyke
27	8 September 1933	Van Dyke	2	Weston
28	[ca. September 1933]	Weston	3	Van Dyke
29	2 October 1933	Weston	1	Van Dyke
30	[ca. November 1933]	Weston	2	Van Dyke
31	28 December 1933	Weston	4	Van Dyke
32	10 January 1934	Weston	4	Van Dyke
33	[ca. January 1934]	Van Dyke	1	Weston
34	20 January 1934	Weston	2	Van Dyke
35	[ca. 1 February 1934]	Weston	2★	Van Dyke
36	5 February 1934	Weston	2	Van Dyke

Letter	Date	Author	Pages	Collection
37	16 March 1934	Weston	2	Van Dyke
38	31 March 1934	Weston	1	Van Dyke
39	[1934?]	Weston	2	Van Dyke
40	20 August [1934?]	Van Dyke	1	Weston
41	15 September 1934	Van Dyke	2	Weston
42	[1935]	Van Dyke	2	Weston
43	[ca. April 1937]	Van Dyke	1	Weston
44	[ca. April 1937]	Van Dyke	1	Weston
45	[ca. April 1937]	Van Dyke	1	Weston
46	[ca. July 1937]	Van Dyke	1	Weston
47	27 February 1938	Van Dyke	2	Weston
48	28 March 1938	Weston	5	Van Dyke
49	18 April 1938	Weston	5+	Van Dyke
50	16 June 1938	Weston	3	Van Dyke
51	21 February 1939	Van Dyke	2	Weston
52	4 November 1939	Weston	3	Van Dyke
53	6 November 1939	Van Dyke	1	Weston
54	8 March 1943	Weston	5	Van Dyke
55	[ca. July 1944]	Weston	4	Van Dyke
56	21 July 1945	Van Dyke	1	Weston
57	7 July 1948	Van Dyke	1	Weston
58	21 January [1950]	Van Dyke	2	Weston
59	3 March 1950	Van Dyke	1	Weston
60	14 May 1950	Van Dyke	2	Weston
61	8 July 1950	Van Dyke	2	Weston
62	[1951?]	Weston	1	Van Dyke
63	3 January 1951	Van Dyke	2	Weston
64	26 July 1951	Weston	1	Van Dyke
65	25 February 1953	Weston	2	Van Dyke
66	21 December 1953	Van Dyke	2	Weston
67	11 January 1954	Weston	1	Van Dyke
68	28 May 1954	Van Dyke	1	Weston
69	16 January 1956	Van Dyke	3	Weston
70	[ca. January 1956]	Weston	1	Van Dyke
71	31 June 1956	Weston	1	Van Dyke
72	8 October 1956	Van Dyke	3	Weston
73	28 April 1957	Weston	1	Van Dyke
74	30 April 1957	Van Dyke	5	Weston

Selective Index

The following names of people, places, and exhibitions have been selectively drawn from the letters and notes. The first numbers after the terms in the list indicate the letter in which the term appears. The numbers in italics refer to the note in which the term appears. For example *n32* refers to Note 32. The terms have not been indexed by page numbers.